THE AMERICANS

THE AMERICANS

Photographs by **ROBERT FRANK**

Introduction by **JACK KEROUAC**

STEIDL / NATIONAL GALLERY OF ART, WASHINGTON

INTRODUCTION
by Jack Kerouac

THAT CRAZY FEELING IN AMERICA when the sun is hot on the streets and music comes out of the jukebox or from a nearby funeral, that's what Robert Frank has captured in tremendous photographs taken as he traveled on the road around practically forty-eight states in an old used car (on Guggenheim Fellowship) and with the agility, mystery, genius, sadness and strange secrecy of a shadow photographed scenes that have never been seen before on film. For this he will definitely be hailed as a great artist in his field. After seeing these pictures you end up finally not knowing any more whether a jukebox is sadder than a coffin. That's because he's always taking pictures of jukeboxes and coffins—and intermediary mysteries like the Negro priest squatting underneath the bright liquid belly *mer* of the Mississippi at Baton Rouge for some reason at dusk or early dawn with a white snowy cross and secret incantations never known outside the bayou—Or the picture of a chair in some cafe with the sun coming in the window and setting on the chair in a holy halo I never thought could be caught on film much less described in its beautiful visual entirety in words.

The humor, the sadness, the EVERYTHING-ness and American-ness of these pictures! Tall thin cowboy rolling butt outside Madison Square Garden New York for rodeo season, sad, spindly, unbelievable—Long shot of night road arrowing forlorn into immensities and flat of impossible-to-believe America in New Mexico under the prisoner's moon—under the whang whang guitar star—Haggard old frowsy dames of Los Angeles leaning peering out the right front window of Old Paw's car on a Sunday gawking and criticizing to explain Amerikay to little children in the spattered back seat—tattoed guy sleeping on grass in park in Cleveland, snoring dead to the world on a Sunday afternoon with too many balloons and sailboats—Hoboken in the winter, platform full of politicians all ordinary looking till suddenly at the far end to the right you see one of them pursing his lips in prayer politico (yawning probably) not a soul cares—Old man standing hesitant with oldman cane under old steps long since torn down—Madman resting under American flag canopy in old busted car seat in fantastic Venice California backyard, I could sit in it and sketch 30,000 words (as a railroad brakeman I rode by such backyards leaning out of the old steam pot) (empty tokay bottles in the palm weeds)—Robert picks up two hitch hikers and lets them drive the car, at night, and people look at their two faces looking grimly onward into the night ("Visionary Indian angels who *were* visionary angels" says Allen Ginsberg) and people say "Ooo how mean they look" but all they want to do is arrow on down that road and get back to the sack—Robert's here to tell us so—St. Petersburg Florida the retired old codgers on a bench in

the busy mainstreet leaning on their canes and talking about social security and one incredible I think Seminole half Negro woman pulling on her cigarette with thoughts of her own, as pure a picture as the nicest tenor solo in jazz...

As American a picture—the faces don't editorialize or criticize or say anything but "This is the way we are in real life and if you don't like it I don't know anything about it 'cause I'm living my own life my way and may God bless us all, mebbe"... "if we deserve it"...

Oi the lone woe of Lee Lucien, a basketa pittykats...

What a poem this is, what poems can be written about this book of pictures some day by some young new writer high by candlelight bending over them describing every gray mysterious detail, the gray film that caught the actual pink juice of human kind. Whether 't is the milk of human-kindness, Shakespeare meant, makes no difference when you look at these pictures. Better than a show.

Madroad driving men ahead—the mad road, lonely, leading around the bend into the openings of space towards the horizon Wasatch snows promised us in the vision of the west, spine heights at the world's end, coast of blue Pacific starry night—nobone half-banana moons sloping in the tangled night sky, the torments of great formations in mist, the huddled invisible insect in the car racing onward, illuminate—The raw cut, the drag, the butte, the star, the draw, the sunflower in the grass—orangebutted west lands of Arcadia, forlorn sands of the isolate earth, dewy exposures to infinity in black space, home of the rattlesnake and the gopher—the level of the world, low and flat: the

charging restless mute unvoiced road keening in a seizure of tarpaulin power into the route, fabulous plots of landowners in green unexpecteds, ditches by the side of the road, as I look. From here to Elko along the level of this pin parallel to telephone poles I can see a bug playing in the hot sun—swush, hitch yourself a ride beyond the fastest freight train, beat the smoke, find the thighs, spend the shiney, throw the shroud, kiss the morning star in the morning glass—madroad driving men ahead. Pencil traceries of our faintest wish in the travel of the horizon merged, nosey cloud obfusks in a drabble of speechless distance, the black sheep clouds cling a parallel above the steams of C.B.Q.—serried Little Missouri rocks haunt the badlands, harsh dry brown fields roll in the moonlight with a shiny cow's ass, telephone poles toothpick time, "dotting immensity" the crazed voyageur of the lone automobile presses forth his eager insignificance in noseplates & licenses into the vast promise of life. Drain your basins in old Ohio and the Indian and the Illini plains, bring your Big Muddy rivers thru Kansas and the mudlands, Yellowstone in the frozen North, punch lake holes in Florida and L.A., *raise* your cities in the white plain, cast your mountains up, bedawze the west, bedight the west with brave hedgerow cliffs rising to Promethean heights and fame—plant your prisons in the basin of the Utah moon—nudge Canadian groping lands that end in Arctic bays, purl your Mexican ribneck, America—we're going home, going home.

Lying on his satin pillow in the tremendous fame of death, Man, black, mad mourners filing by to take a peek at Holy Face to see what death is like and death is like

life, what else?—If you know what the sutras say—Chicago convention with sleek face earnest wheedling confiding cigarholding union boss fat as Nero and eager as Caesar in the thunderous beer crash hall leaning over to confide—Gaming table at Butte Montana with background election posters and little gambling doodads to knock over, editorial page in itself—

Car shrouded in fancy expensive designed tarpolian (I knew a truckdriver pronounced it "tarpolian") to keep soots of no-soot Malibu from falling on new simonize job as owner who is a two-dollar-an-hour carpenter snoozes in house with wife and TV, all under palm trees for nothing, in the cemeterial California night, ag, ack—In Idaho three crosses where the cars crashed, where that long thin cowboy just barely made it to Madison Square Garden as he was about a mile down the road then—"*I told you to wait in the car*" say people in America so Robert sneaks around and photographs little kids waiting in the car, whether three little boys in a motorama limousine, ompious & opiful, or poor little kids can't keep their eyes open on Route 90 Texas at 4 A.M. as dad goes to the bushes and stretches—The gasoline monsters stand in the New Mexico flats under big sign says SAVE—the sweet little white baby in the black nurse's arms both of them bemused in Heaven, a picture that should have been blown up and hung in the street of Little Rock showing love under the sky and in the womb of our universe the Mother—And the loneliest picture ever made, the urinals that women never see, the shoeshine going on in sad eternity—

Wow, and blown over Chinese cemetery flowers in a San Francisco hill being hammered by potatopatch fog on a March night I'd say nobody there but the rubber cat—

Anybody doesnt like these pitchers dont like potry, see? Anybody dont like potry go home see Television shots of big hatted cowboys being tolerated by kind horses.

Robert Frank, Swiss, unobtrusive, nice, with that little camera that he raises and snaps with one hand he sucked a sad poem right out of America onto film, taking rank among the tragic poets of the world.

To Robert Frank I now give this message: You got eyes.

And I say: That little ole lonely elevator girl looking up sighing in an elevator full of blurred demons, what's her name & address?

THE AMERICANS

Parade — Hoboken, New Jersey

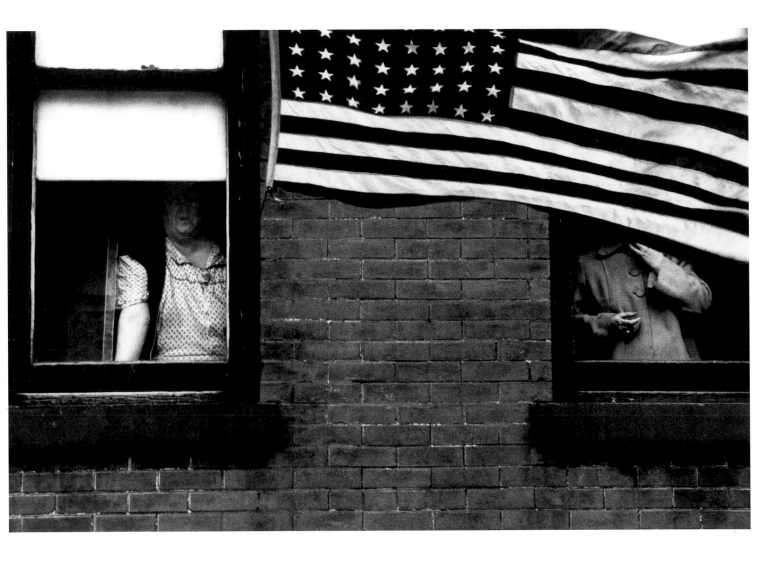

City fathers — Hoboken, New Jersey

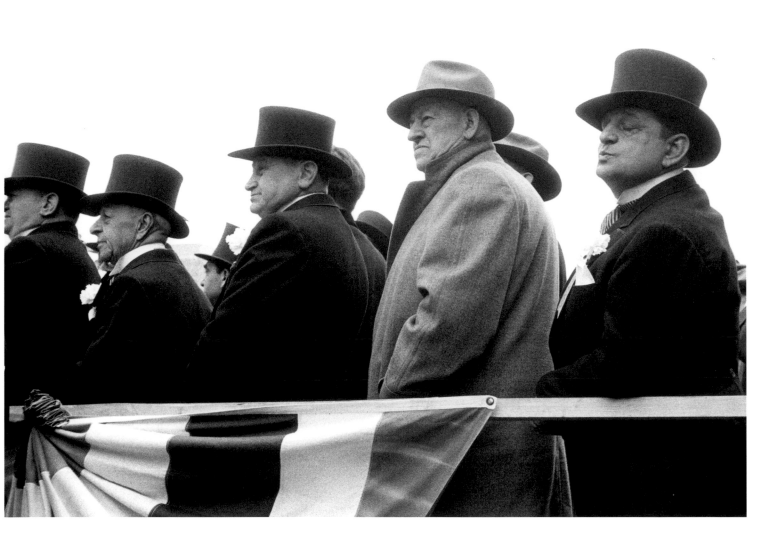

Political rally — Chicago

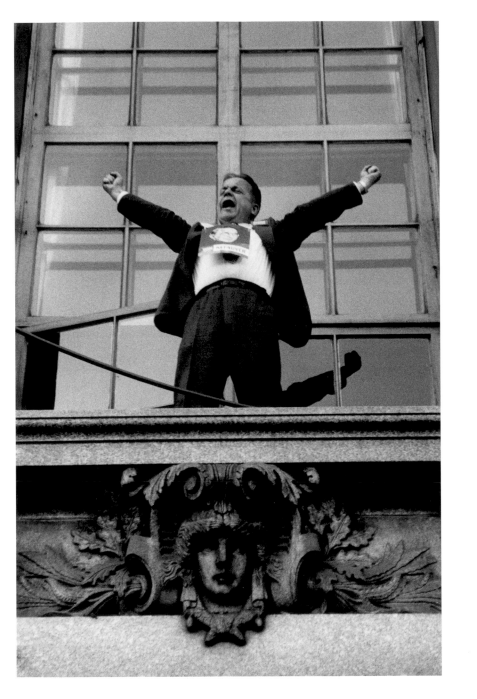

Funeral — St. Helena, South Carolina

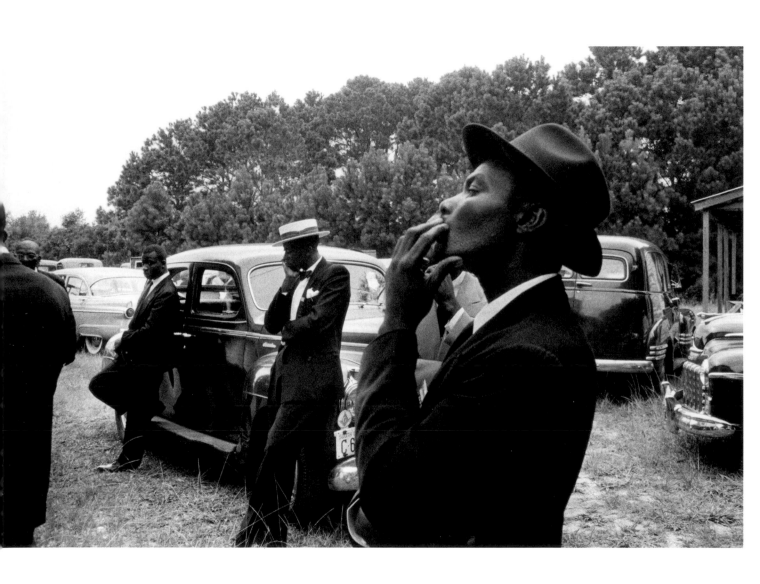

Rodeo — Detroit

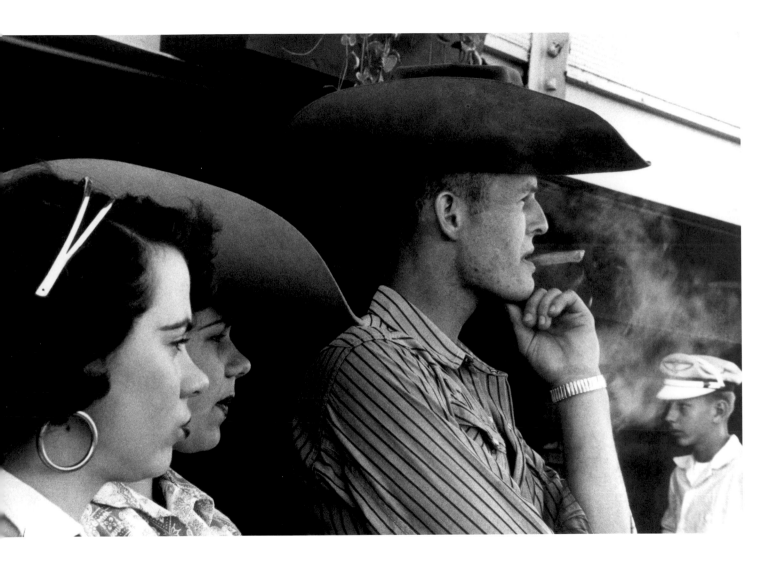

Savannah, Georgia

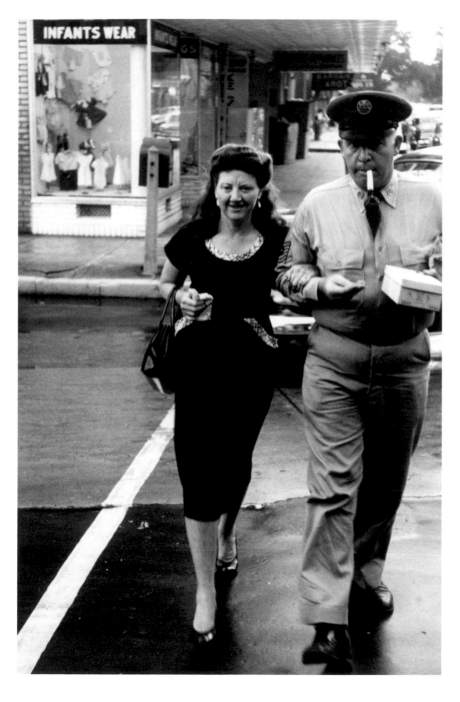

Navy Recruiting Station, Post Office — Butte, Montana

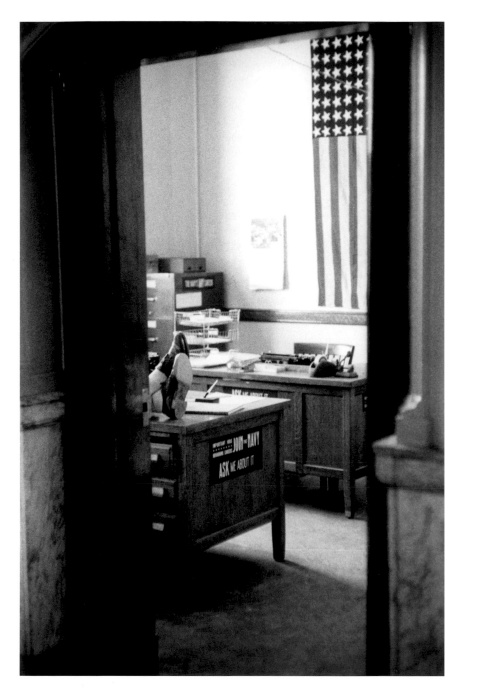

En route from New York to Washington, Club Car

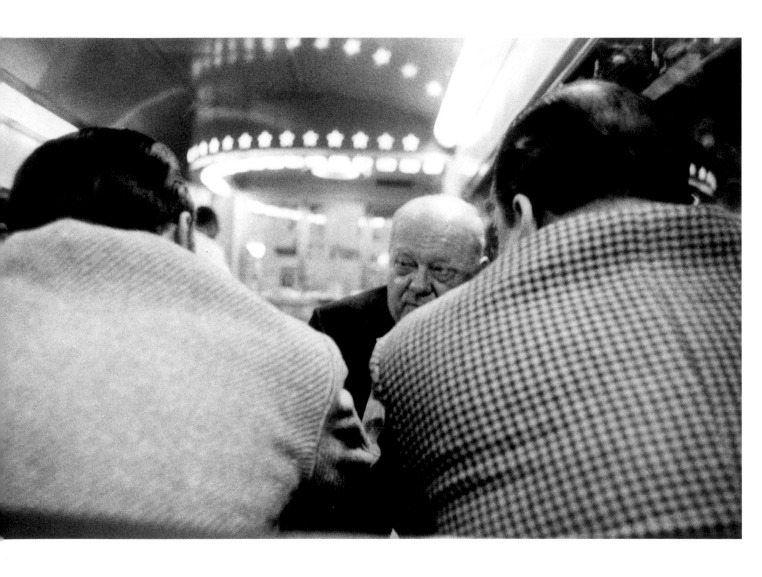

Movie premiere — Hollywood

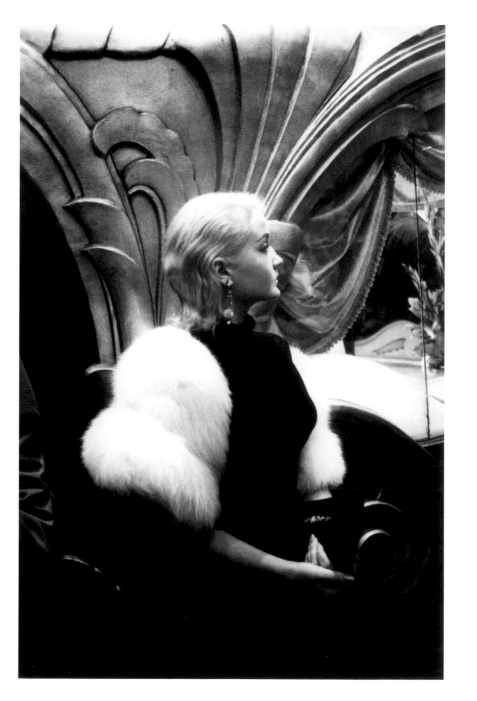

Candy store — New York City

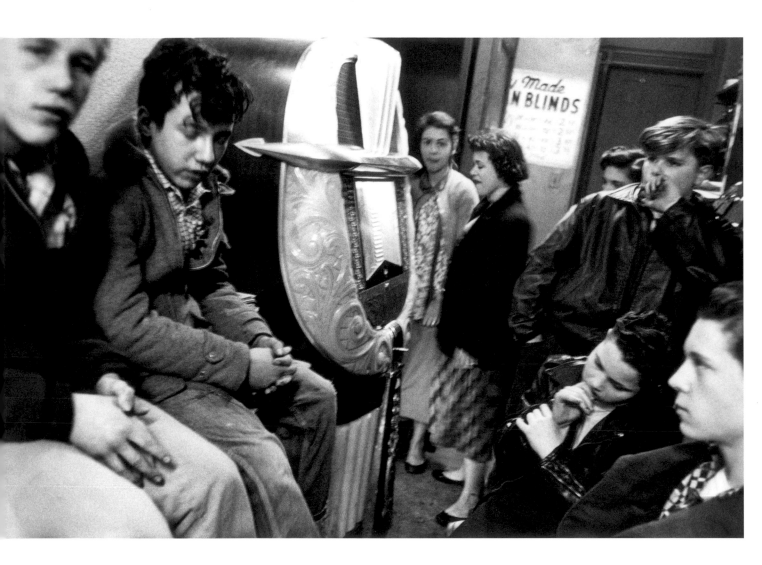

Motorama — Los Angeles

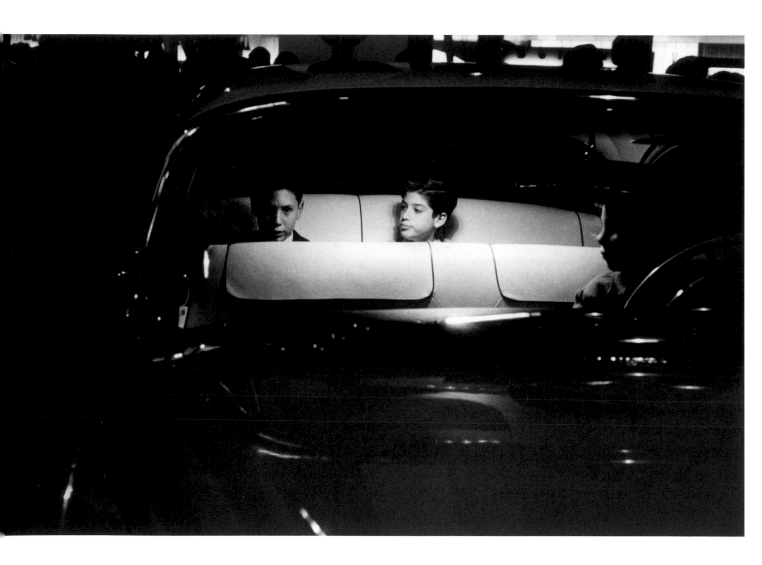

New York City

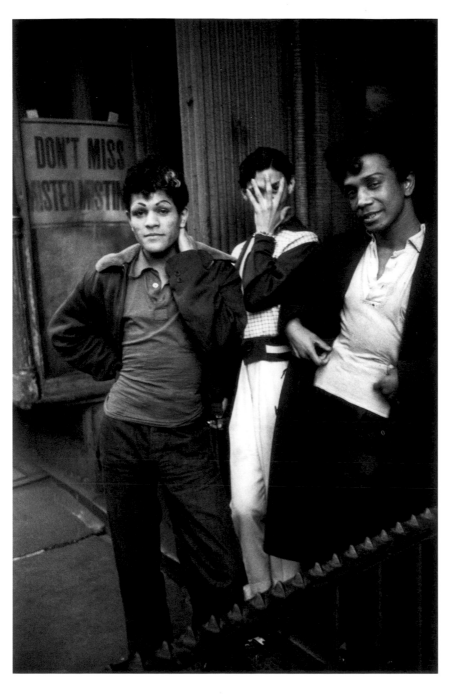

Charleston, South Carolina

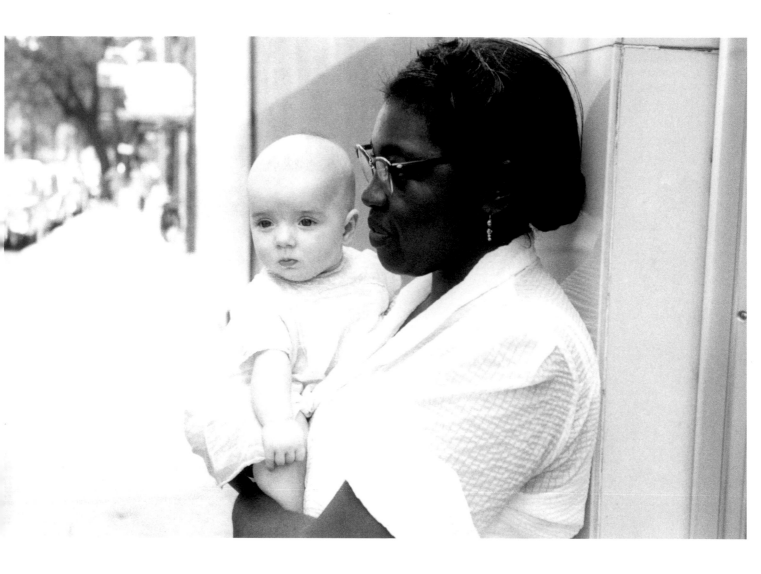

Ranch market — Hollywood

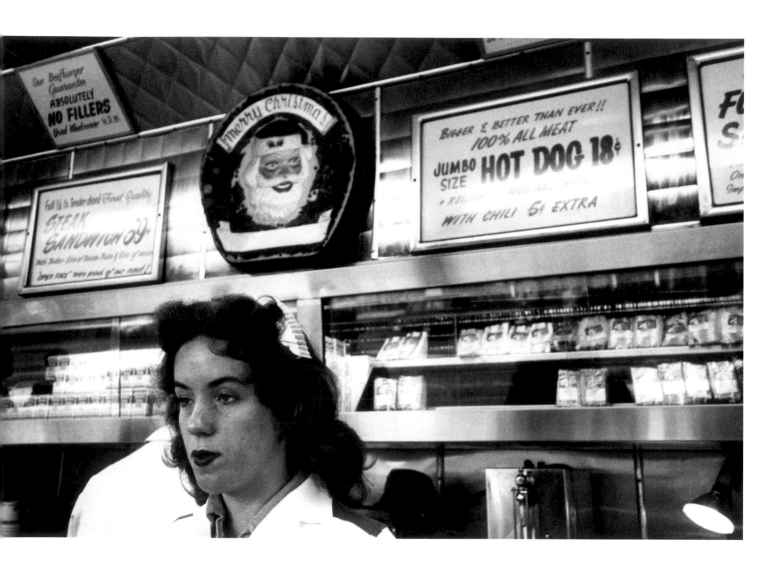

Butte, Montana

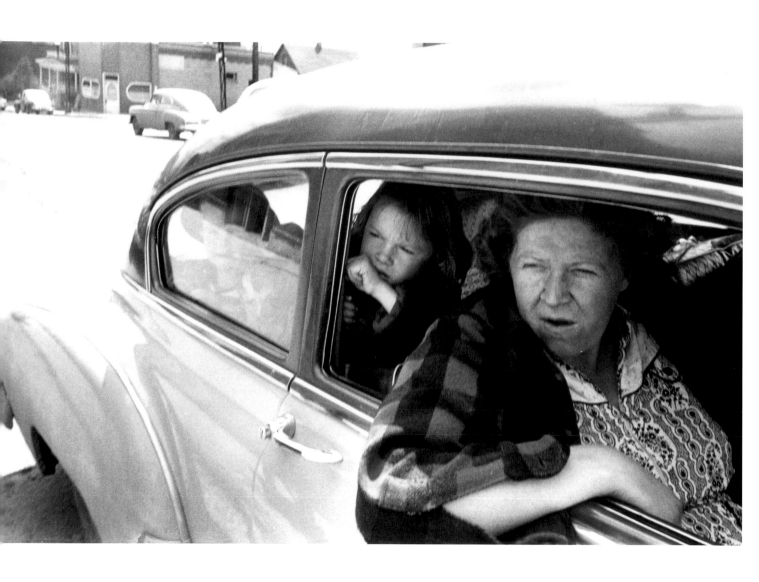

Yom Kippur — East River, New York City

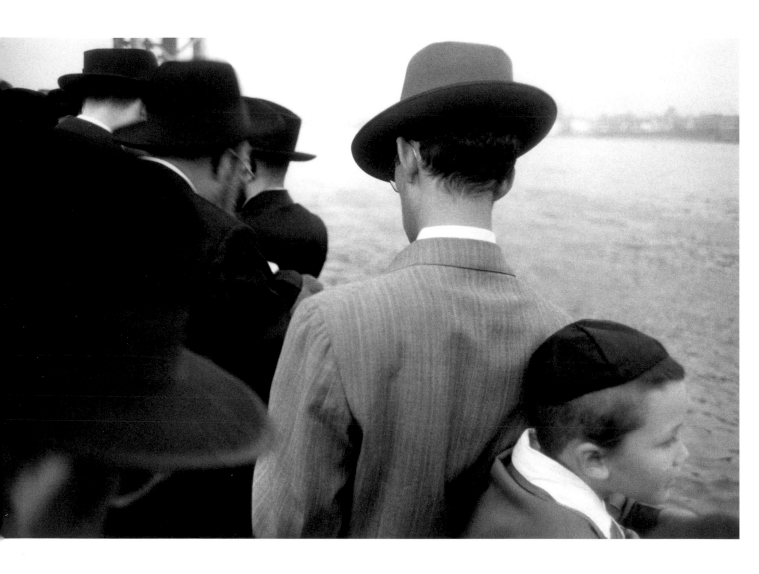

Fourth of July — Jay, New York

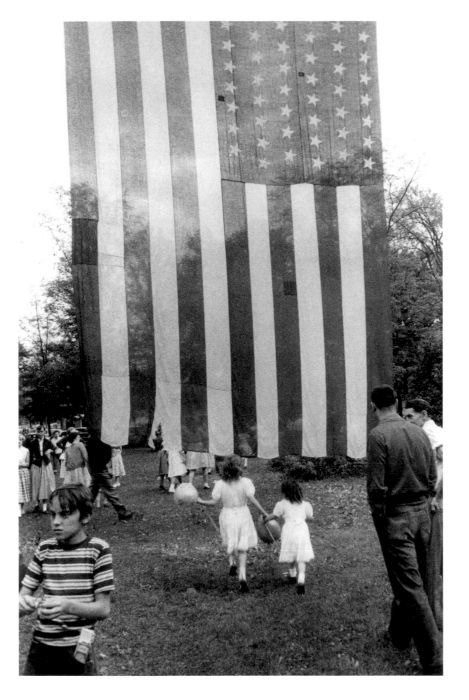

Trolley — New Orleans

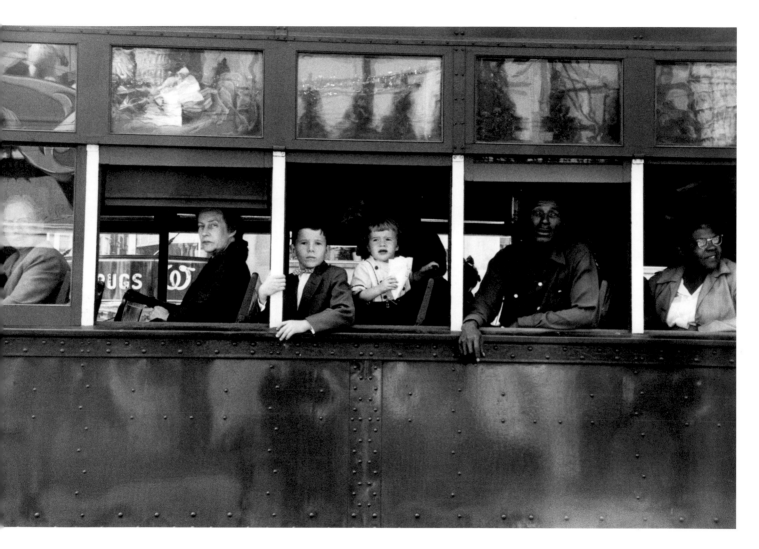

Canal Street — New Orleans

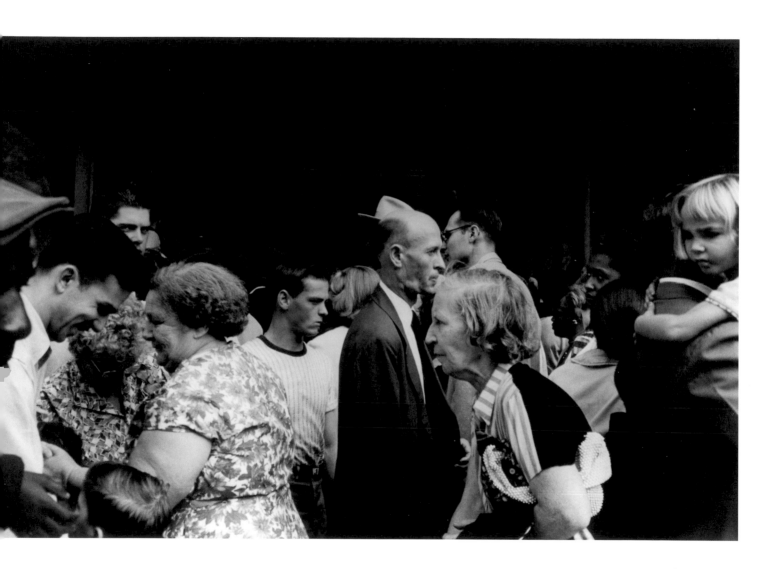

Rooming house — Bunker Hill, Los Angeles

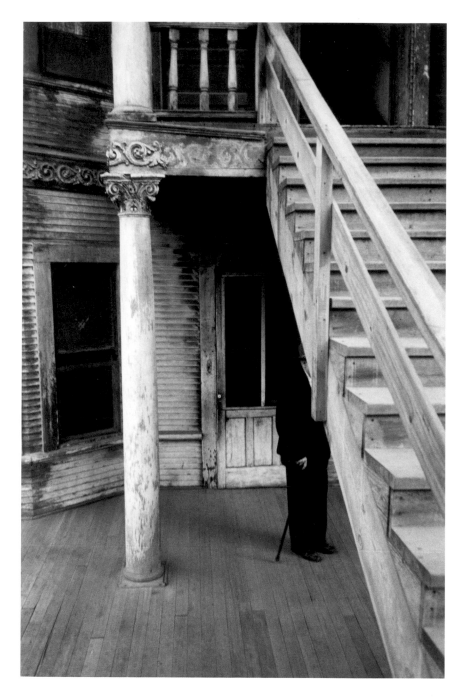

Yale Commencement — New Haven Green, New Haven, Connecticut

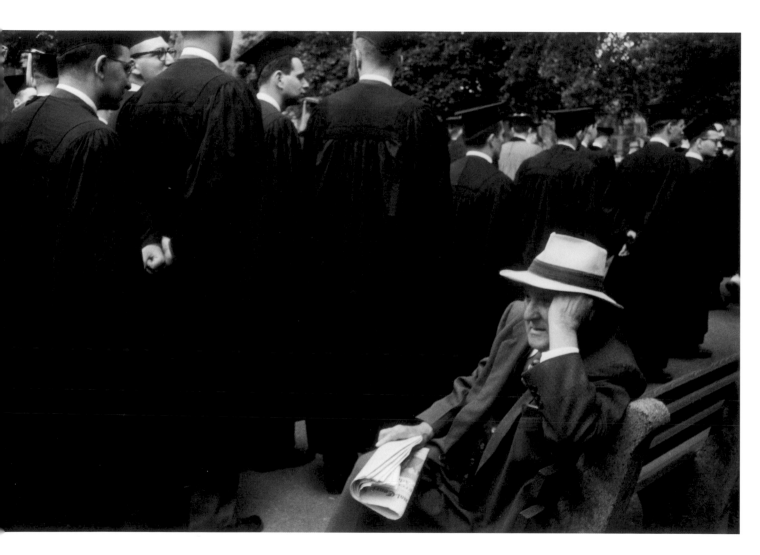

Cafe — Beaufort, South Carolina

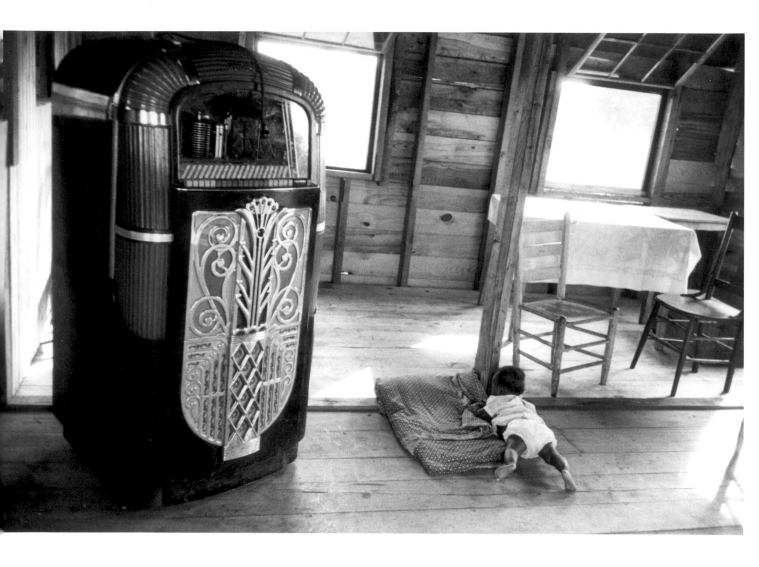

Georgetown, South Carolina

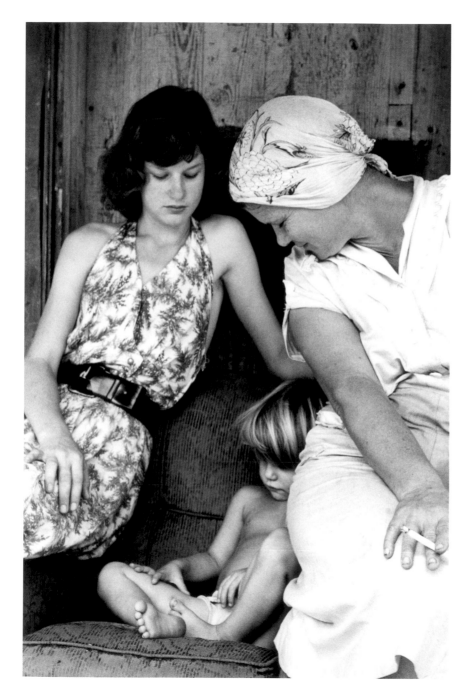

Bar — Las Vegas, Nevada

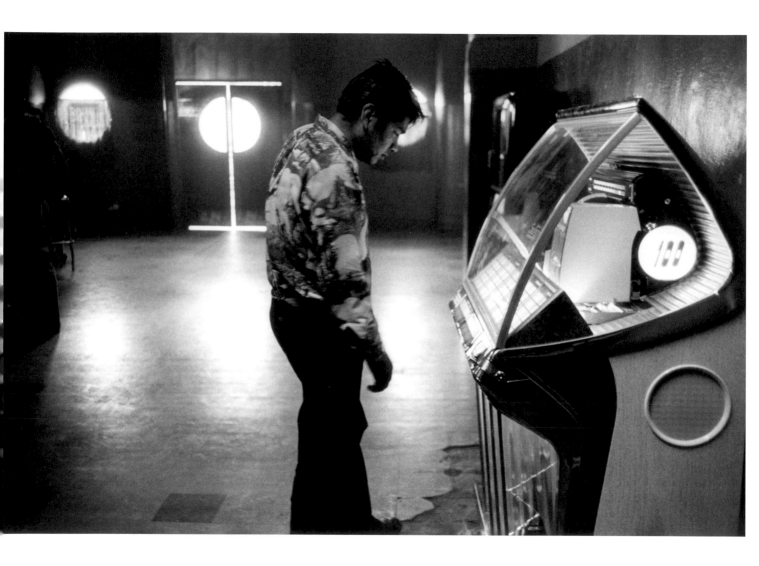

Hotel lobby — Miami Beach

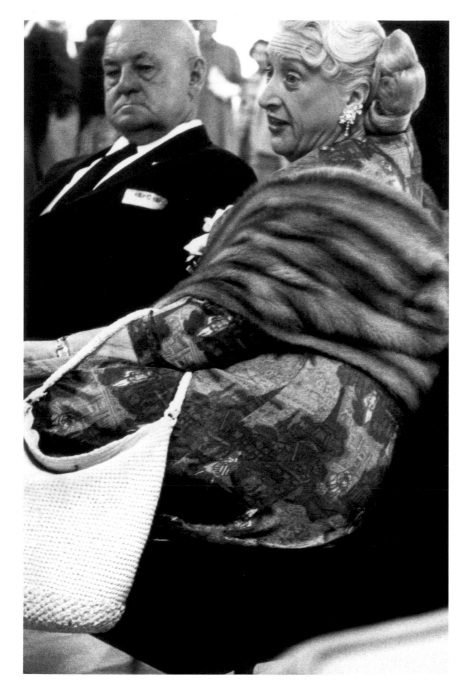

View from hotel window — Butte, Montana

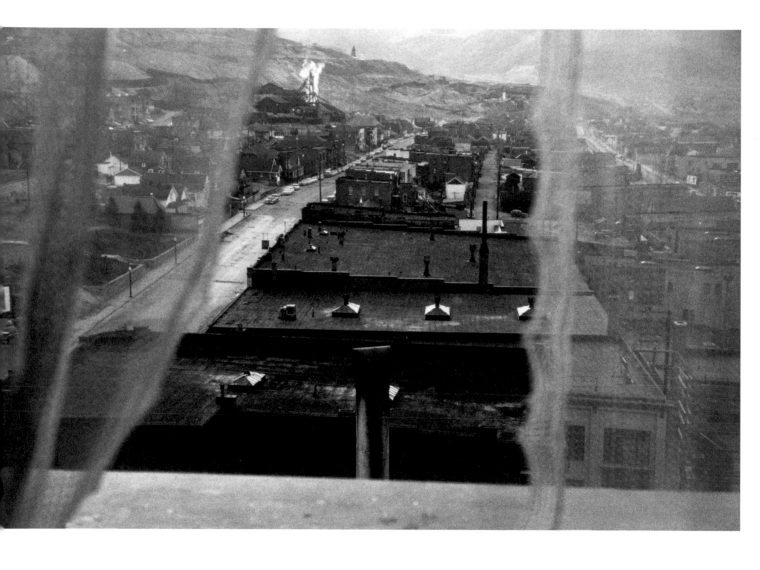

Metropolitan Life Insurance Building — New York City

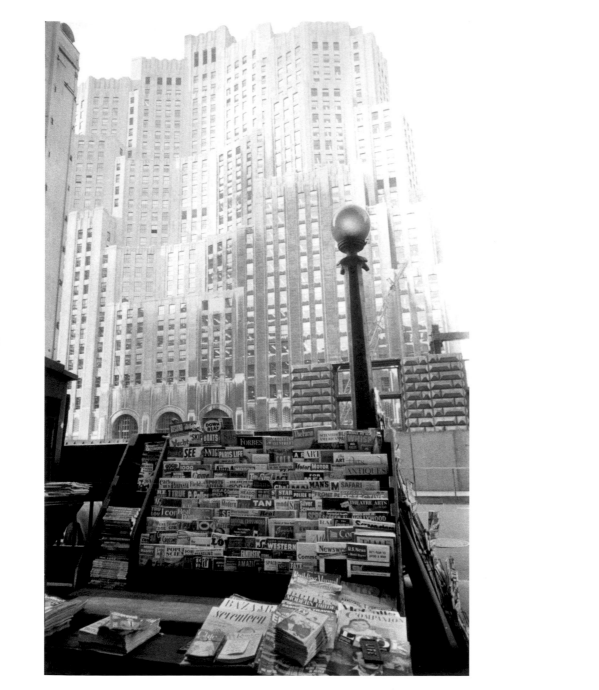

Jehovah's Witness — Los Angeles

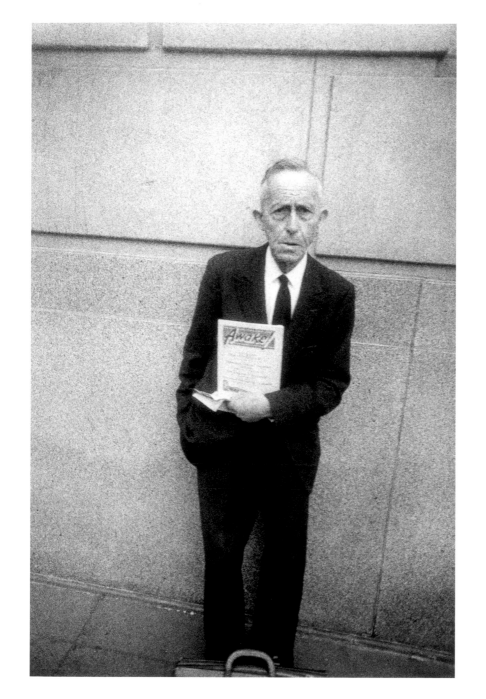

Bar — Gallup, New Mexico

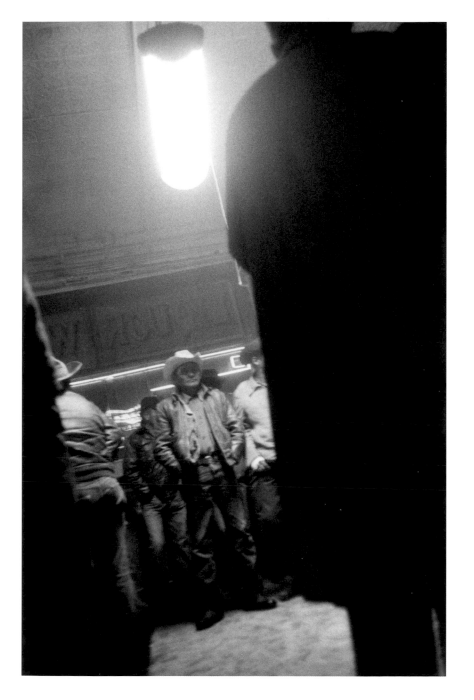

U.S. 30 between Ogallala and North Platte, Nebraska

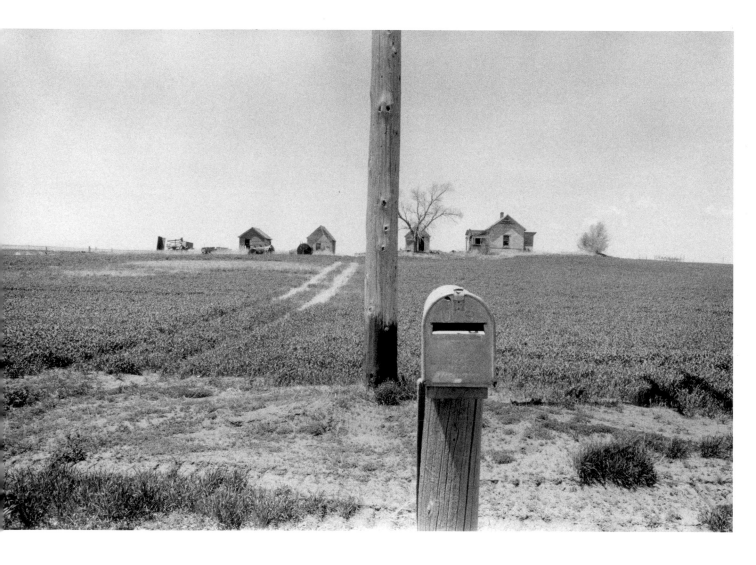

Casino — Elko, Nevada

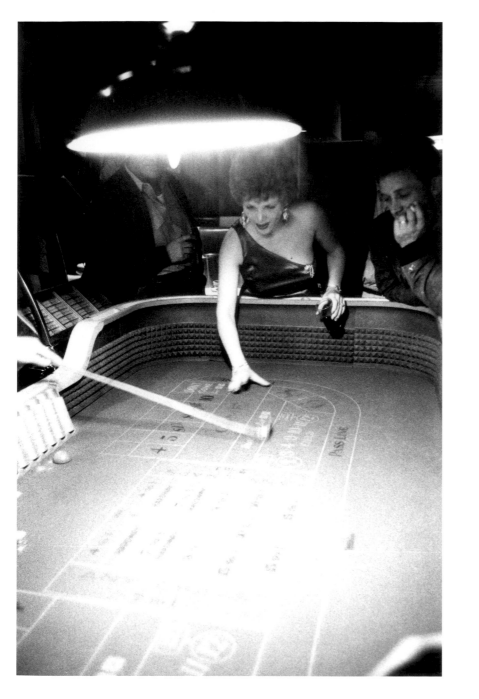

U.S. 91, leaving Blackfoot, Idaho

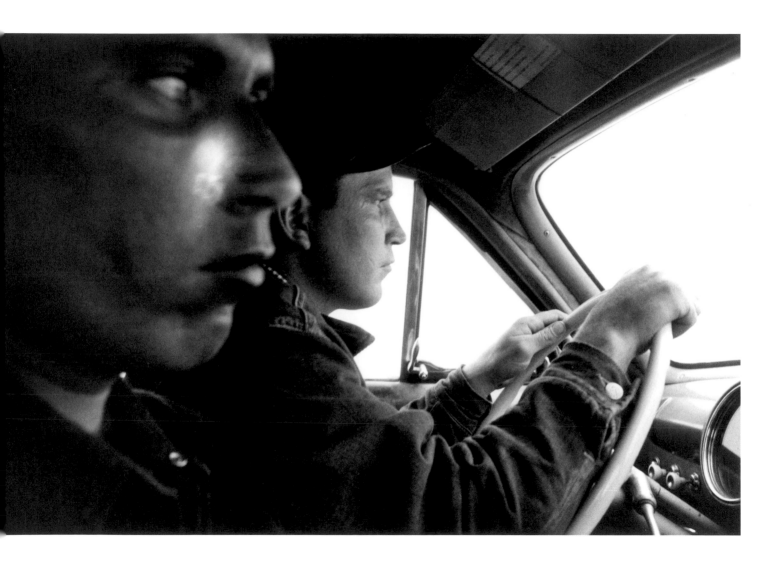

St. Petersburg, Florida

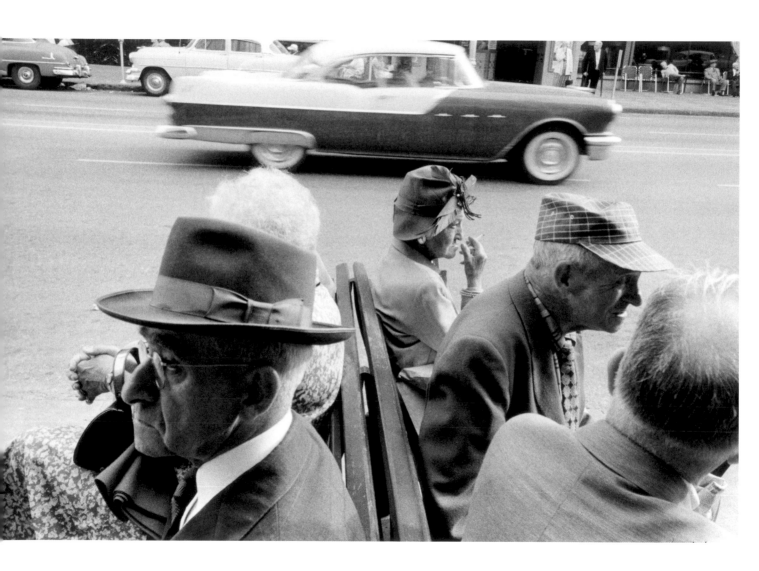

Covered car — Long Beach, California

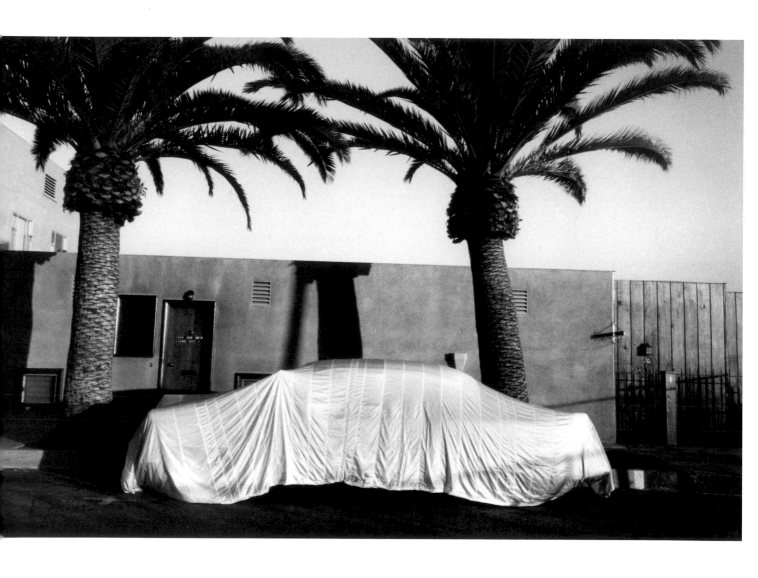

Car accident — U.S. 66, between Winslow and Flagstaff, Arizona

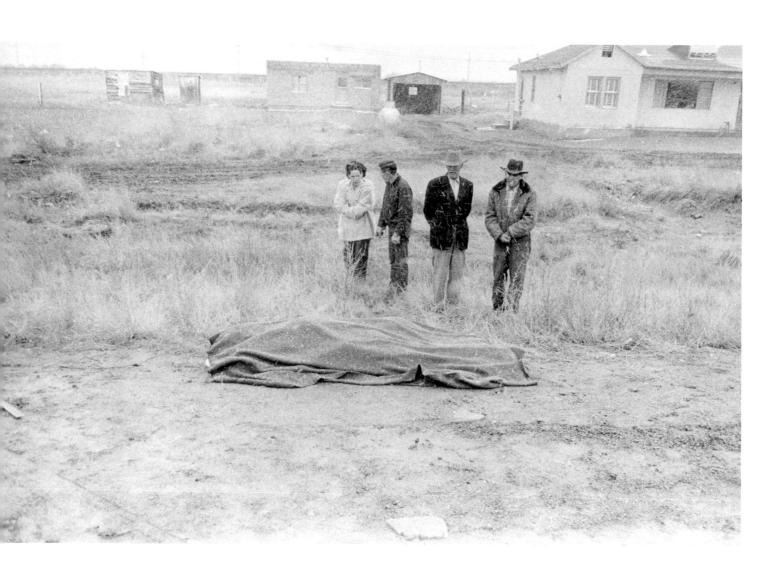

U.S. 285, New Mexico

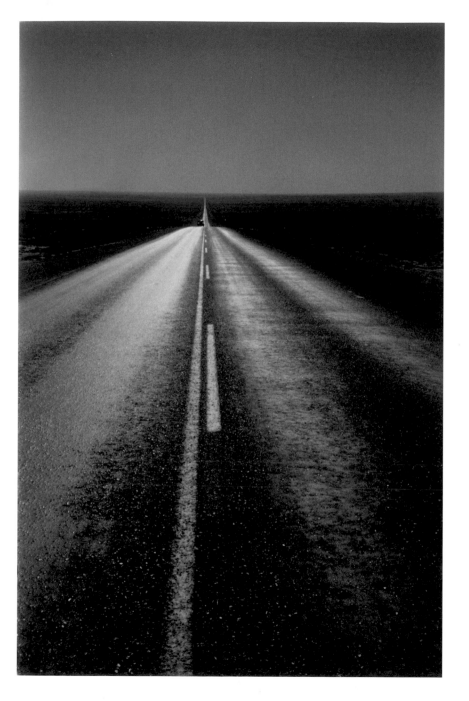

Bar — Detroit

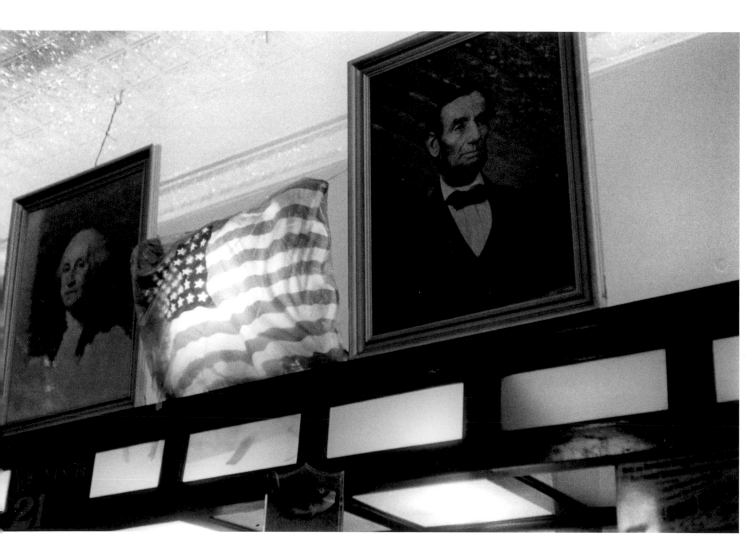

Barber shop through screen door — McClellanville, South Carolina

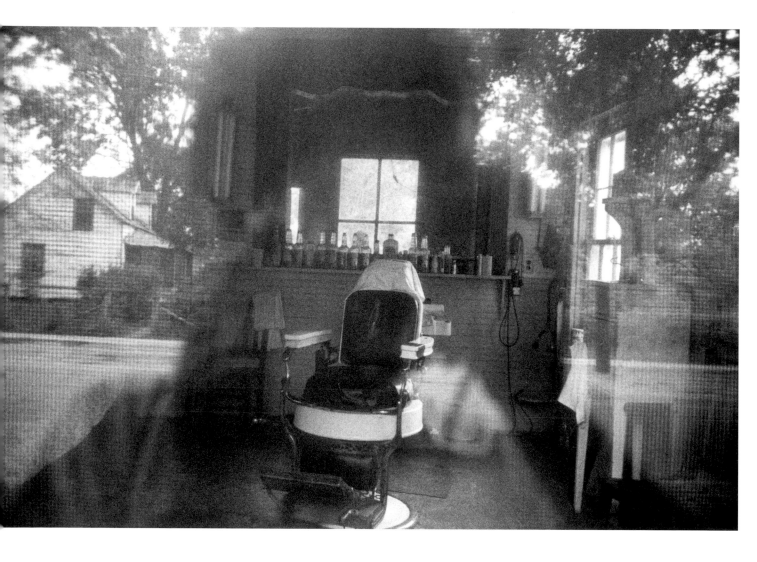

Backyard — Venice West, California

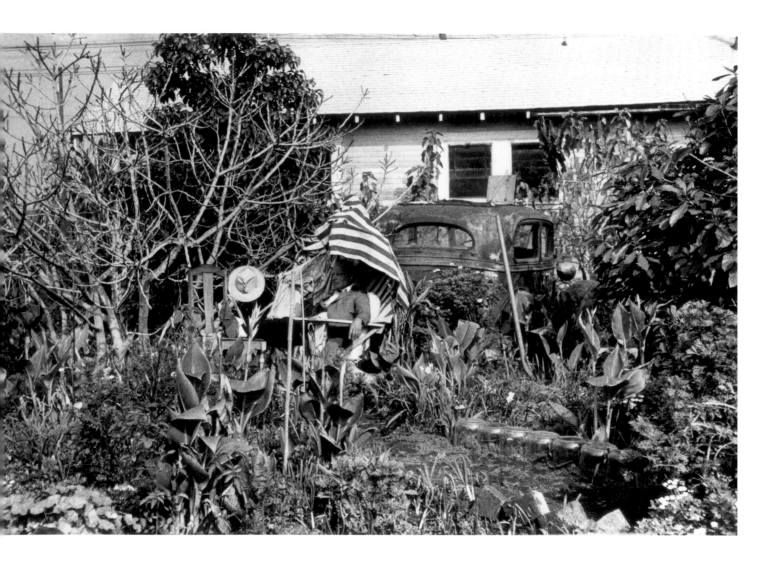

Newburgh, New York

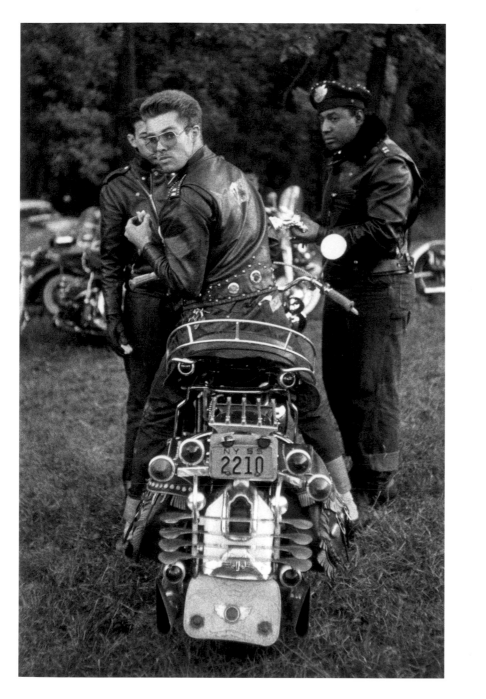

Luncheonette — Butte, Montana

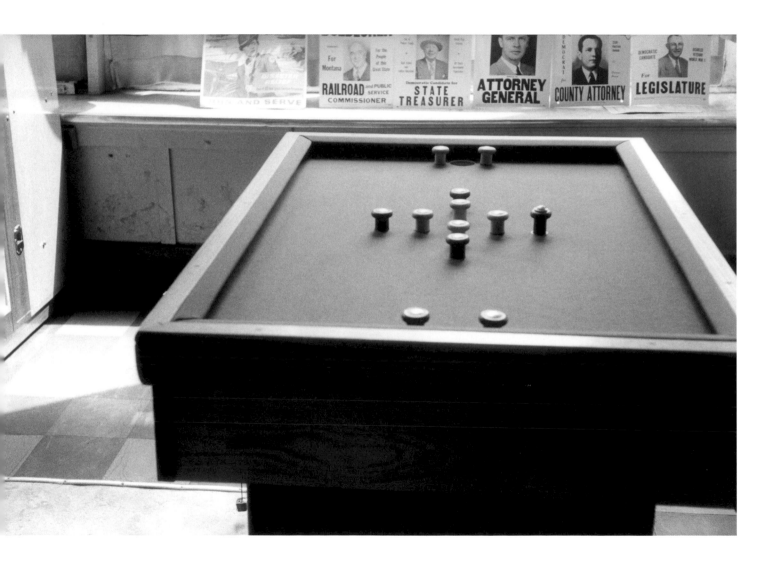

Santa Fe, New Mexico

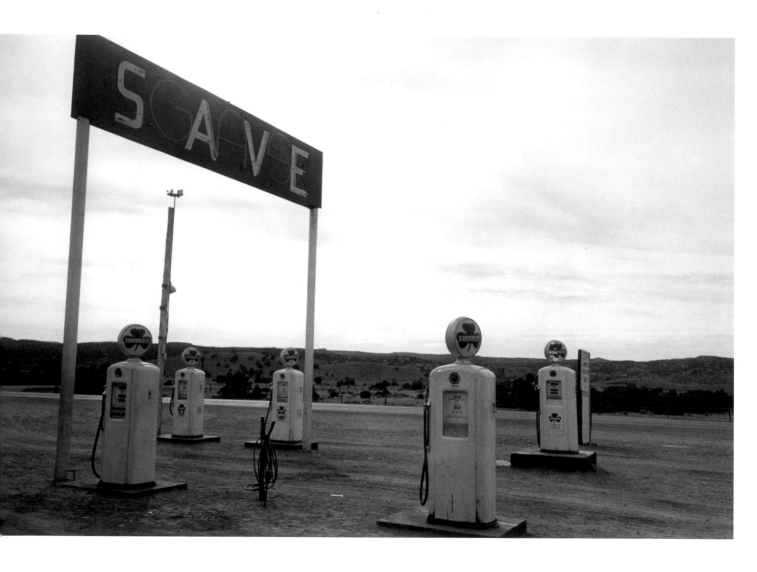

Bar — New York City

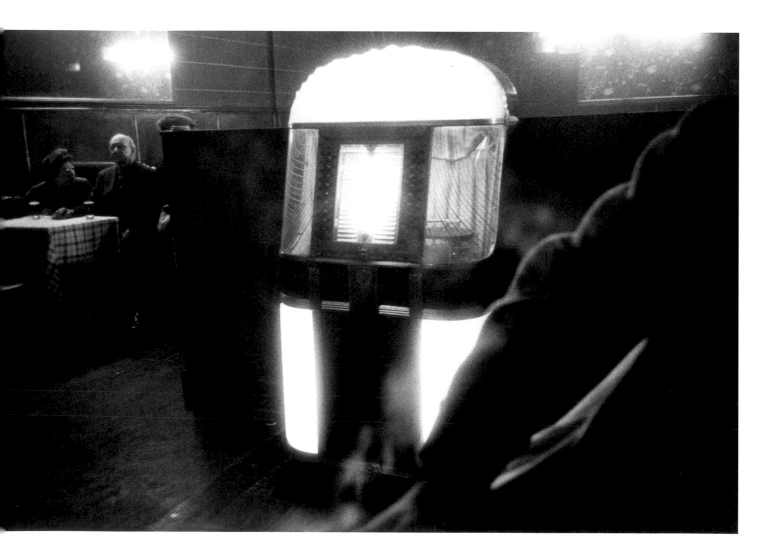

Elevator — Miami Beach

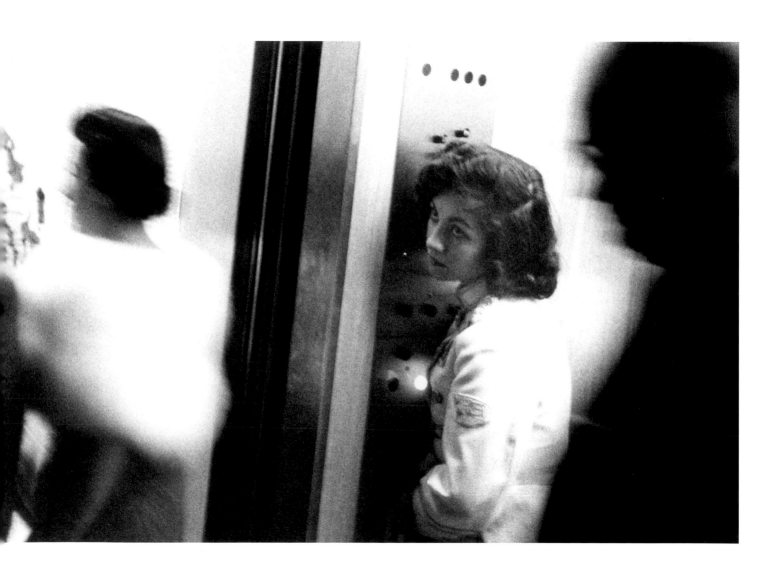

Restaurant — U.S. 1 leaving Columbia, South Carolina

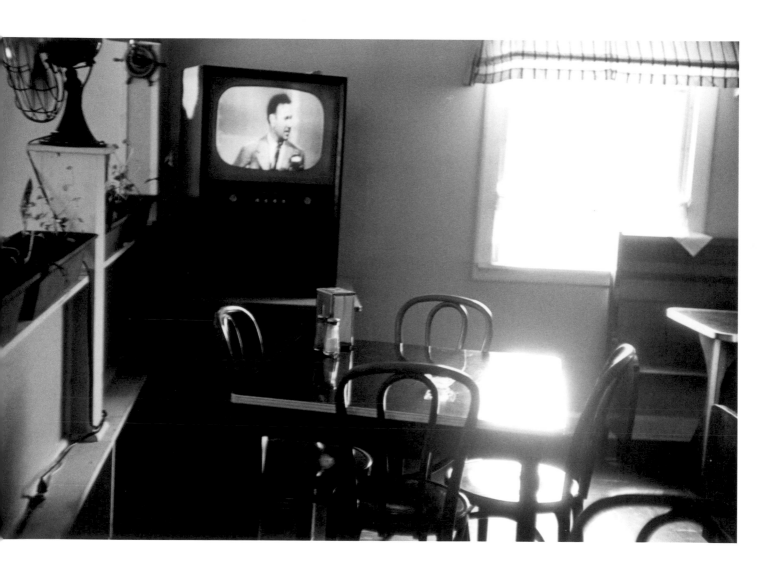

Drive-in movie — Detroit

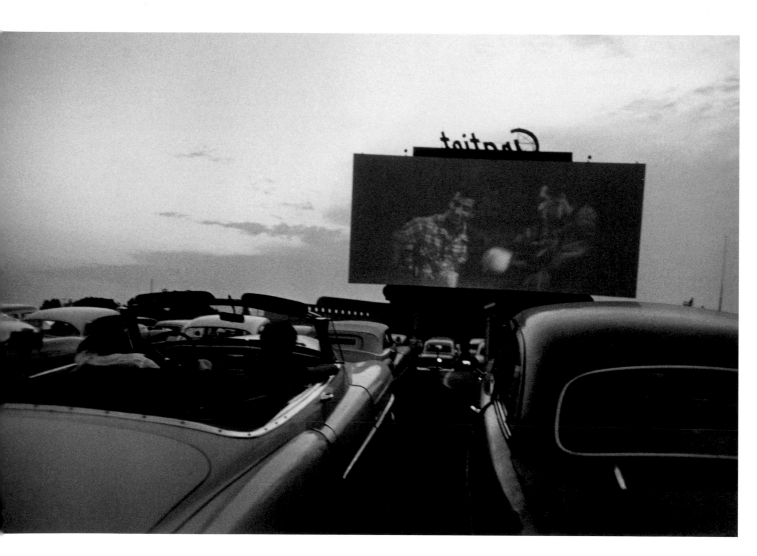

Mississippi River, Baton Rouge, Louisiana

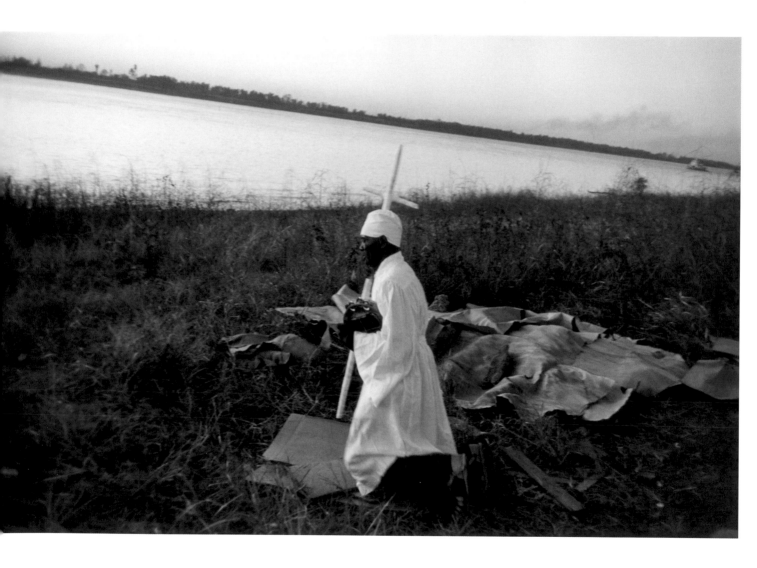

St. Francis, gas station, and City Hall — Los Angeles

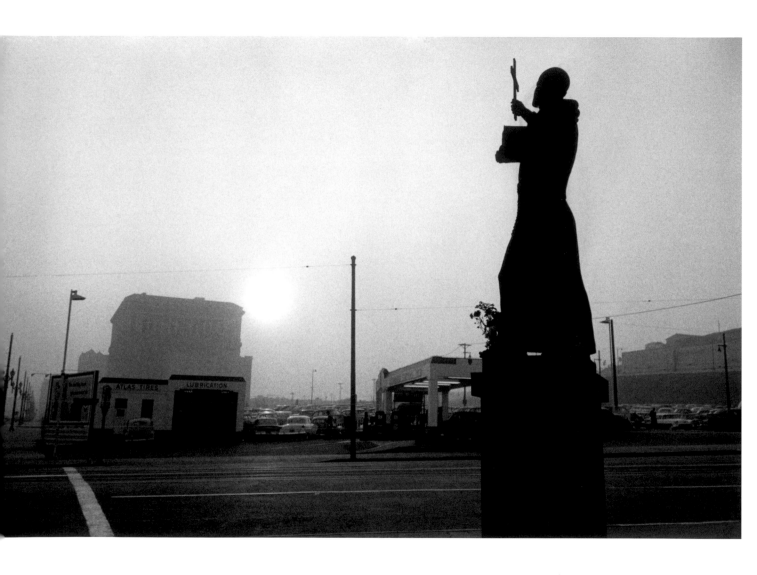

Crosses at scene of highway accident — U.S. 91, Idaho

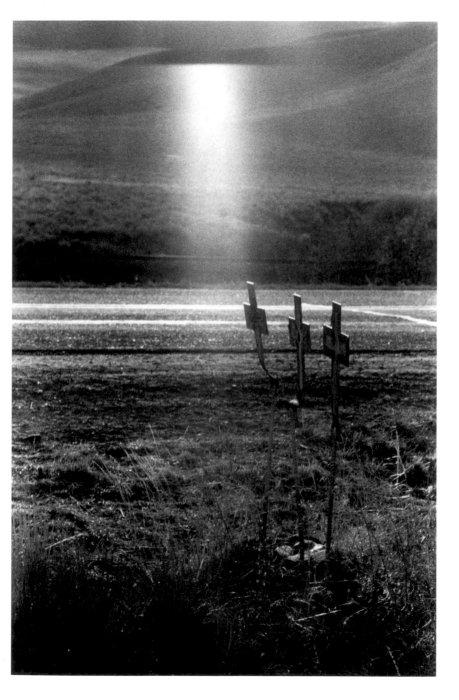

Assembly line — Detroit

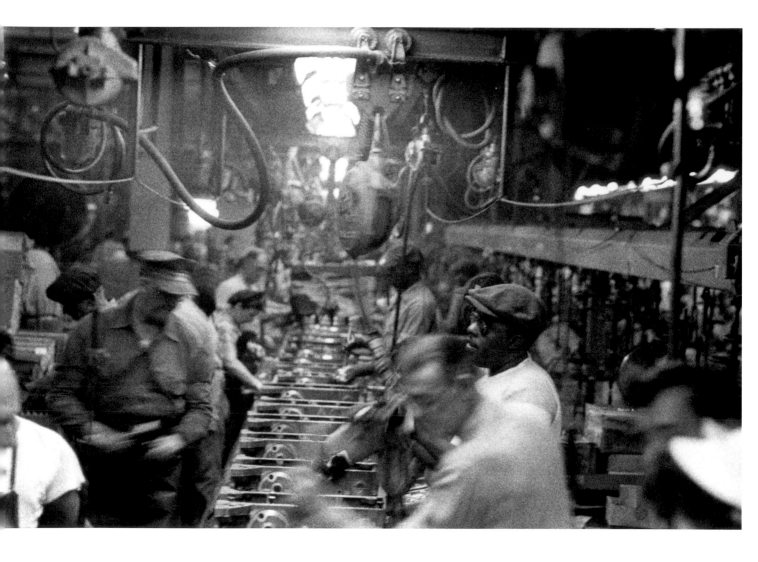

Convention hall — Chicago

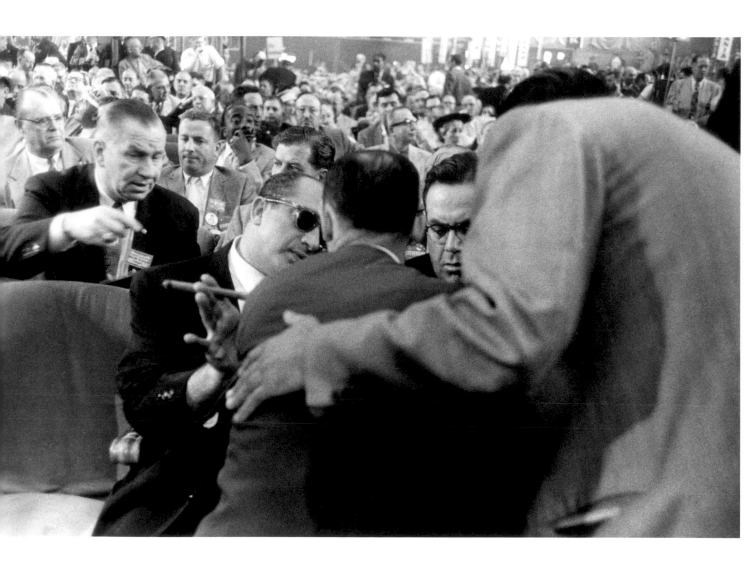

Men's room, railway station — Memphis, Tennessee

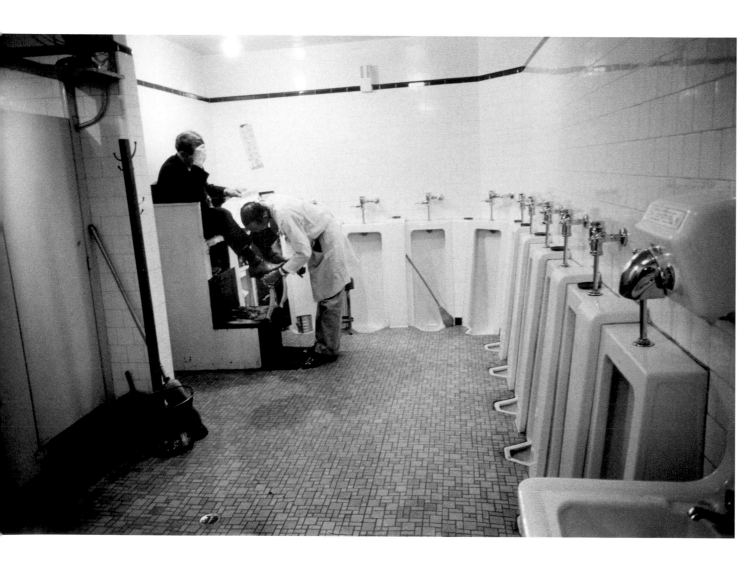

Cocktail party — New York City

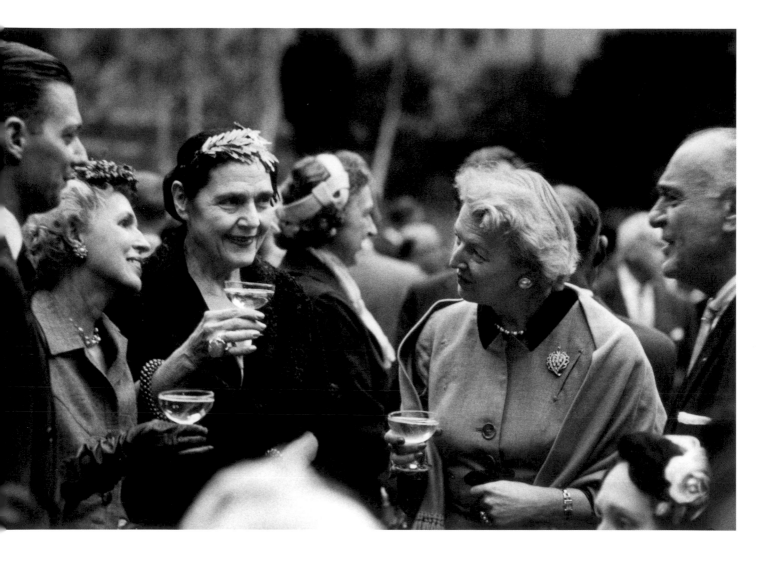

Salt Lake City, Utah

Beaufort, South Carolina

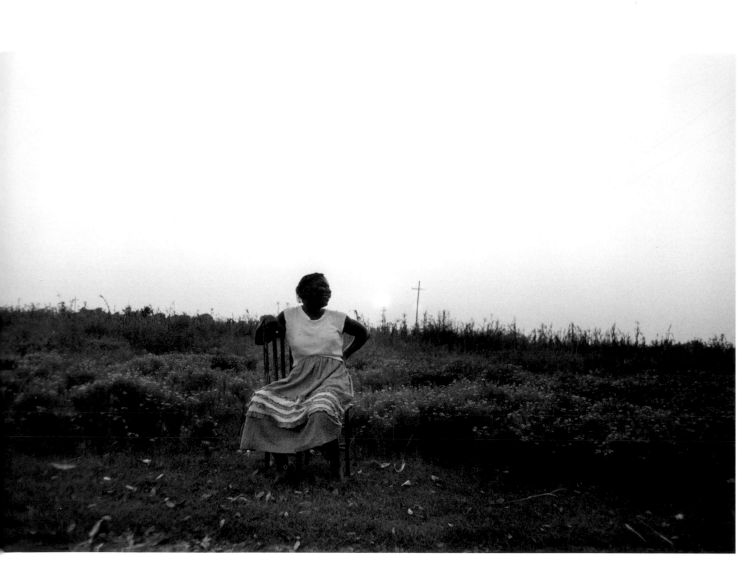

Funeral — St. Helena, South Carolina

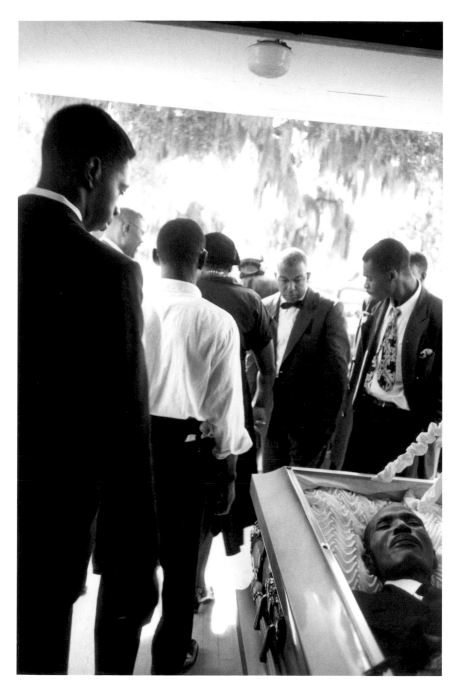

Chinese cemetery — San Francisco

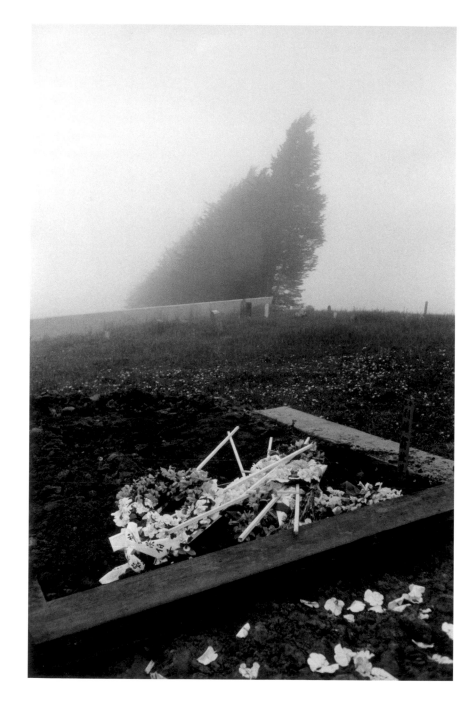

Political rally — Chicago

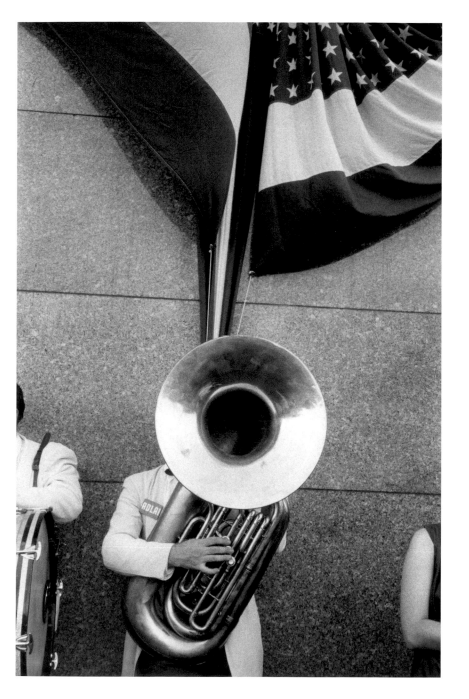

Store window — Washington, D.C.

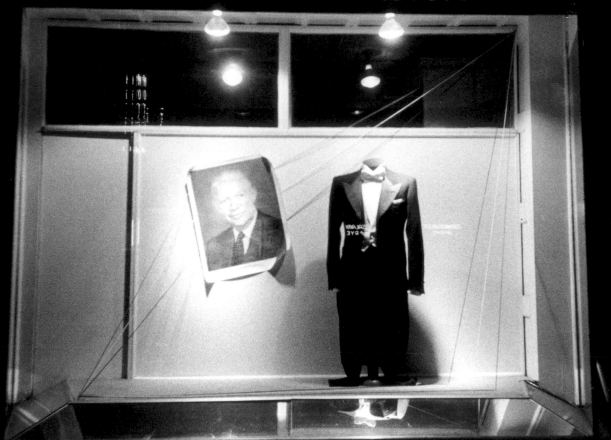

Television studio — Burbank, California

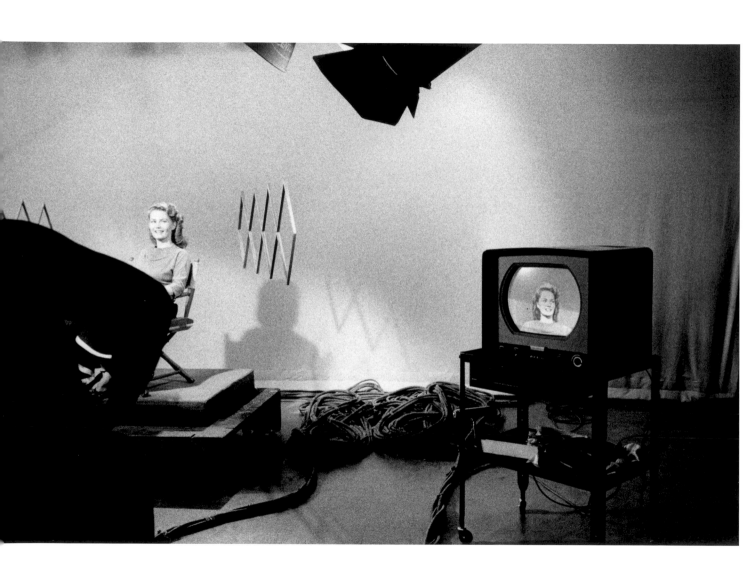

Los Angeles

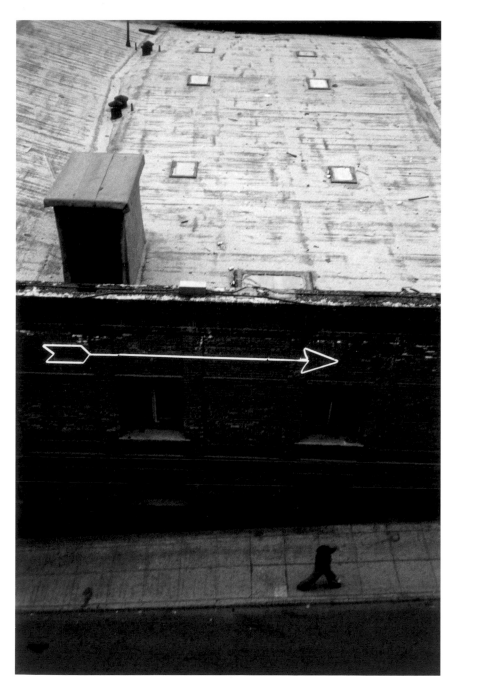

Bank — Houston, Texas

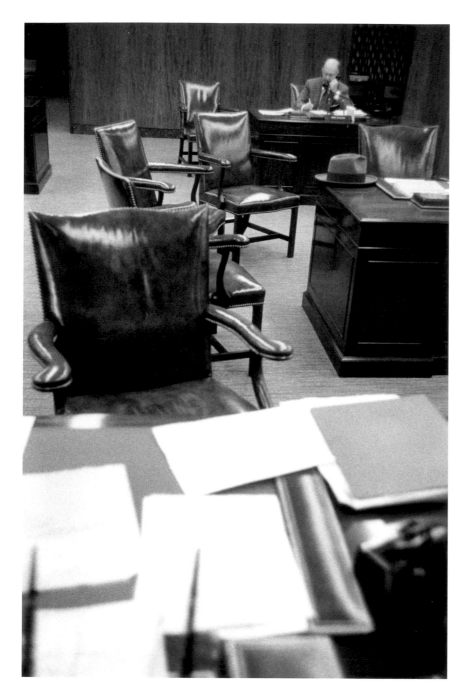

Factory — Detroit

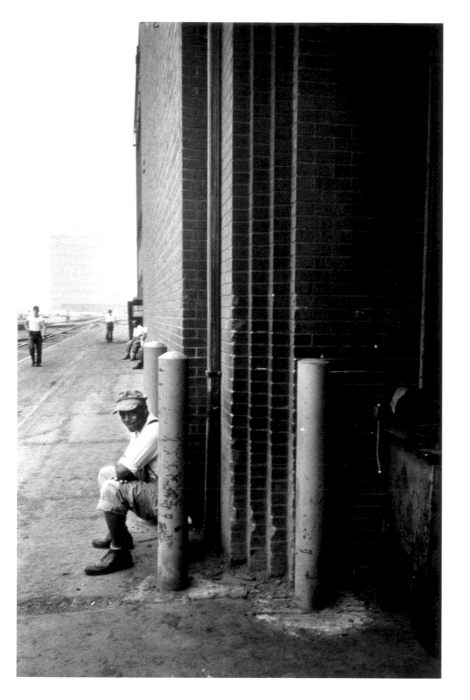

Department store — Lincoln, Nebraska

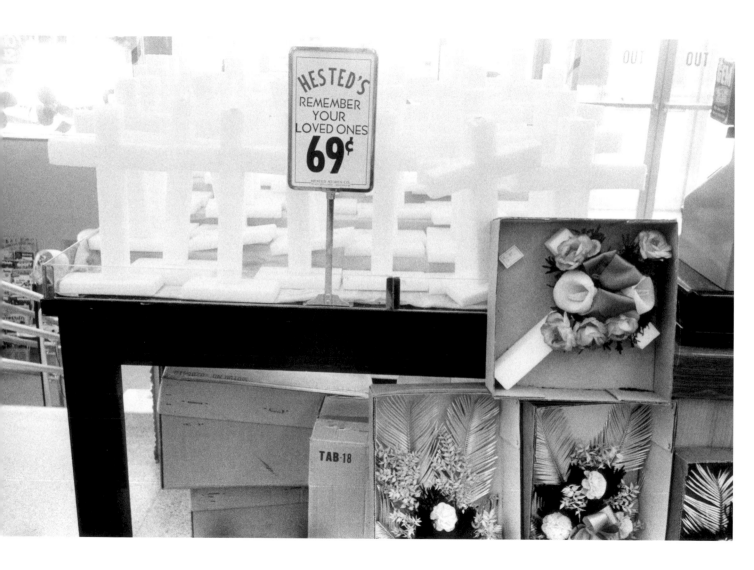

Rodeo — New York City

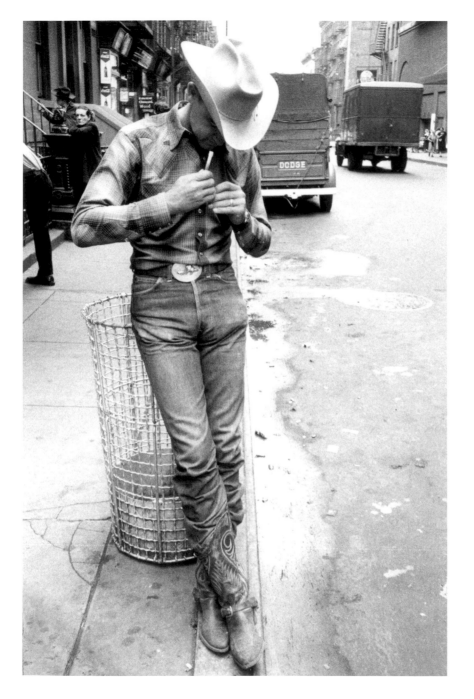

Movie premiere — Hollywood

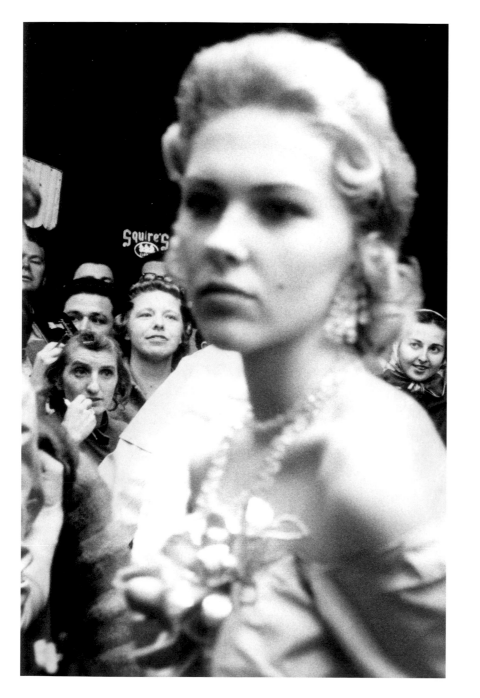

Charity ball — New York City

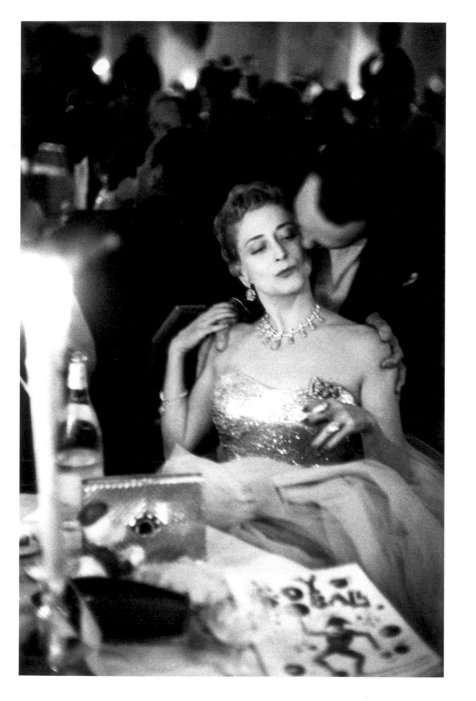

Cafeteria — San Francisco

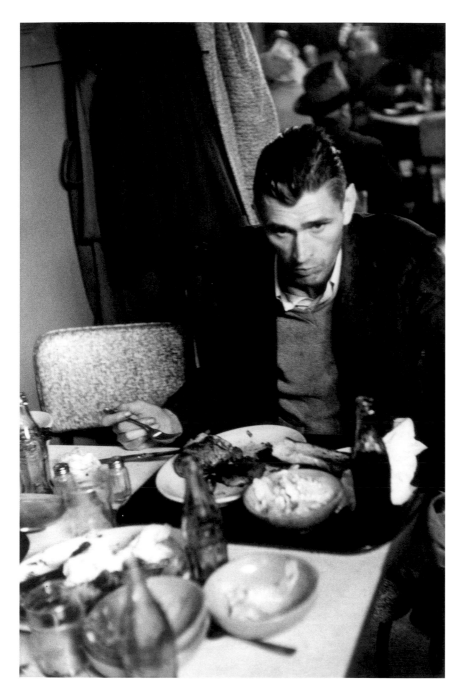

Drug store — Detroit

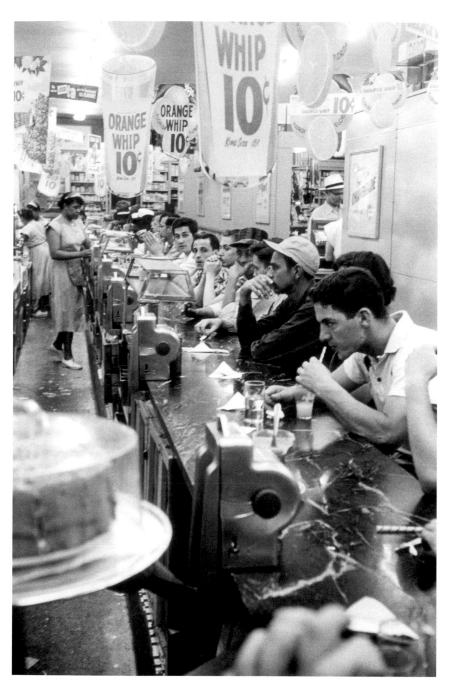

Coffee shop, railway station — Indianapolis

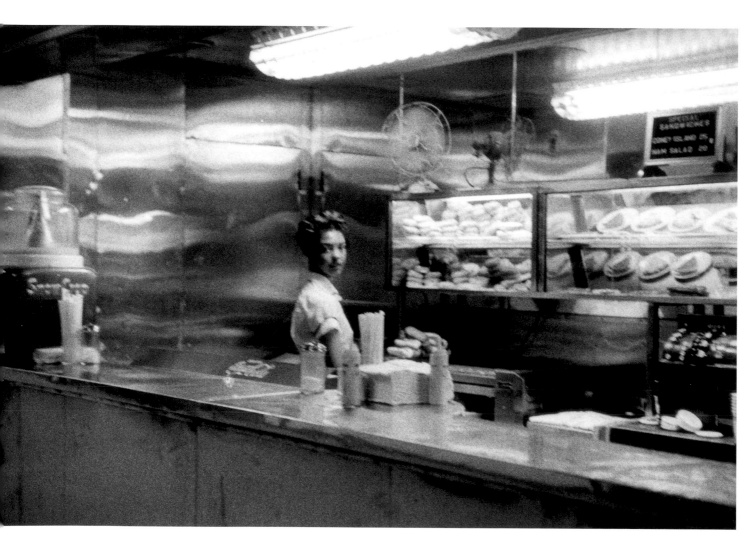

Chattanooga, Tennessee

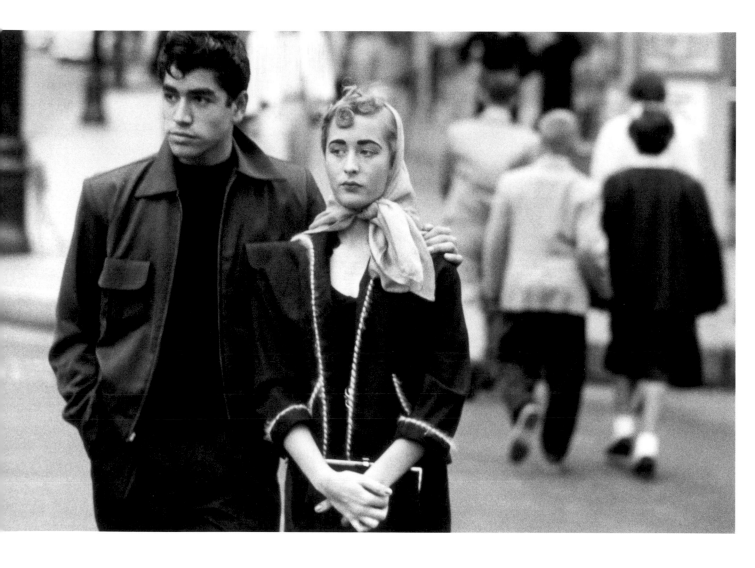

San Francisco

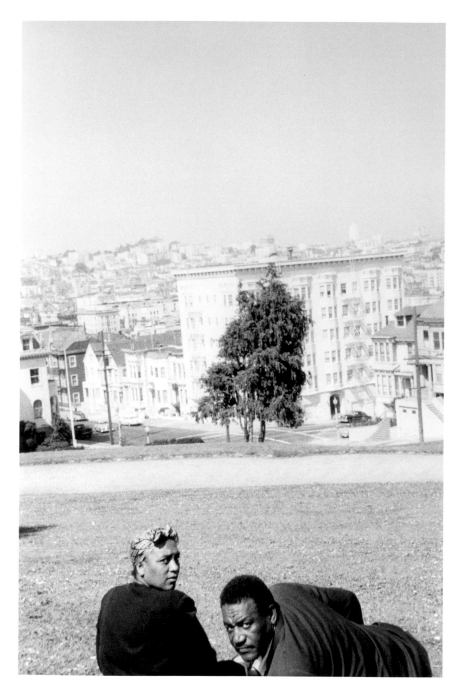

Belle Isle — Detroit

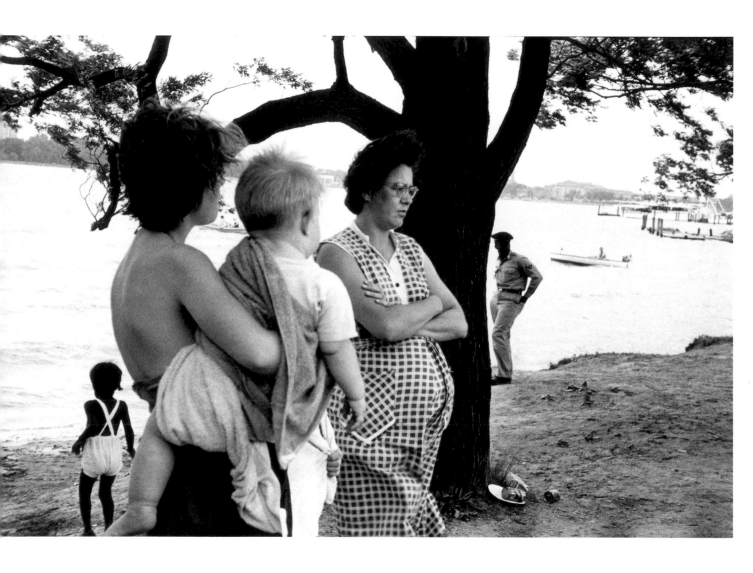

Public park — Cleveland, Ohio

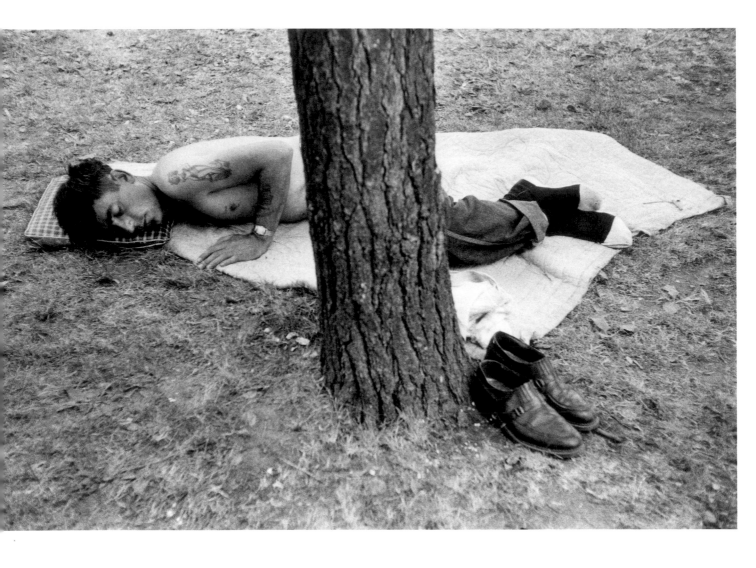

Courthouse square — Elizabethville, North Carolina

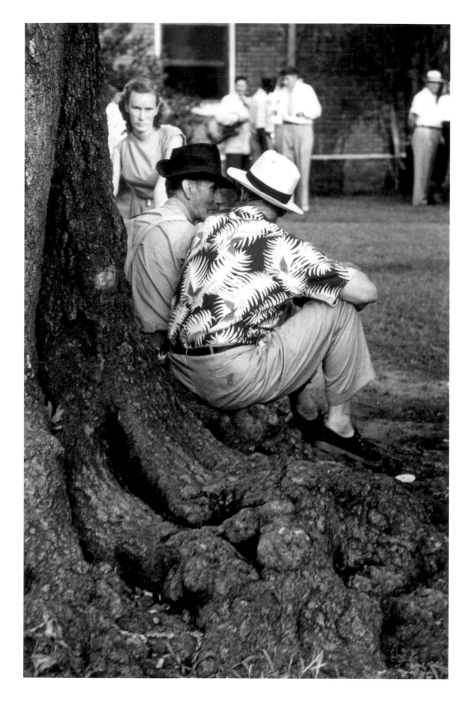

Picnic ground — Glendale, California

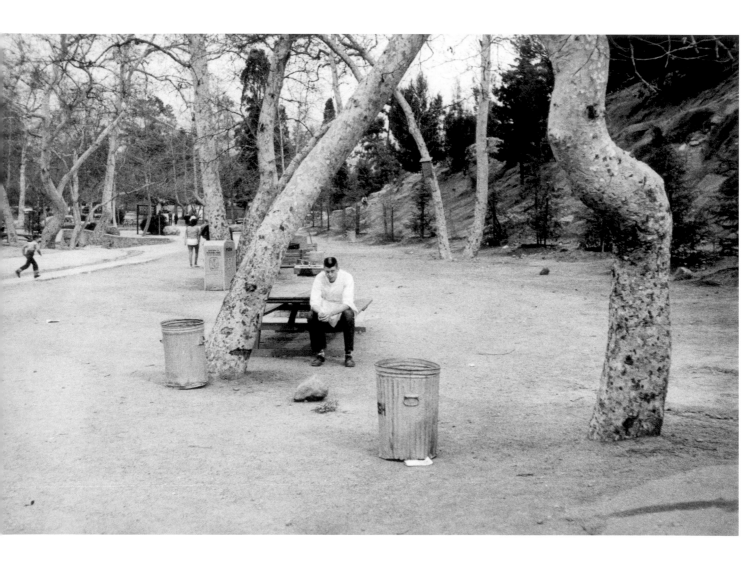

Belle Isle — Detroit

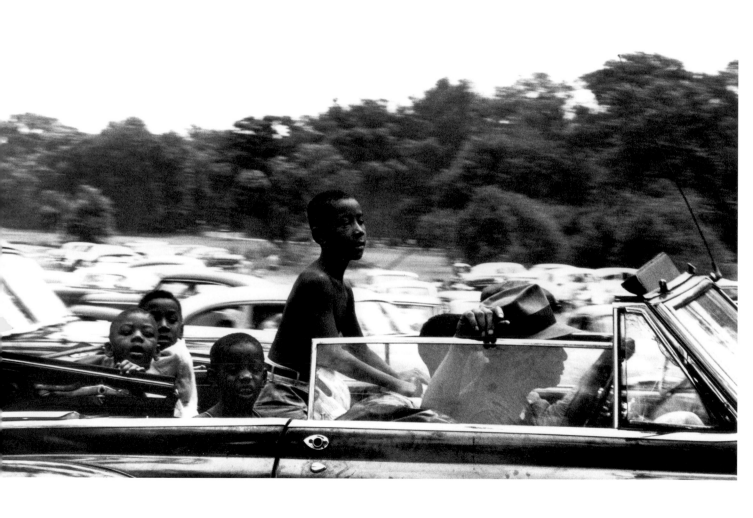

Detroit

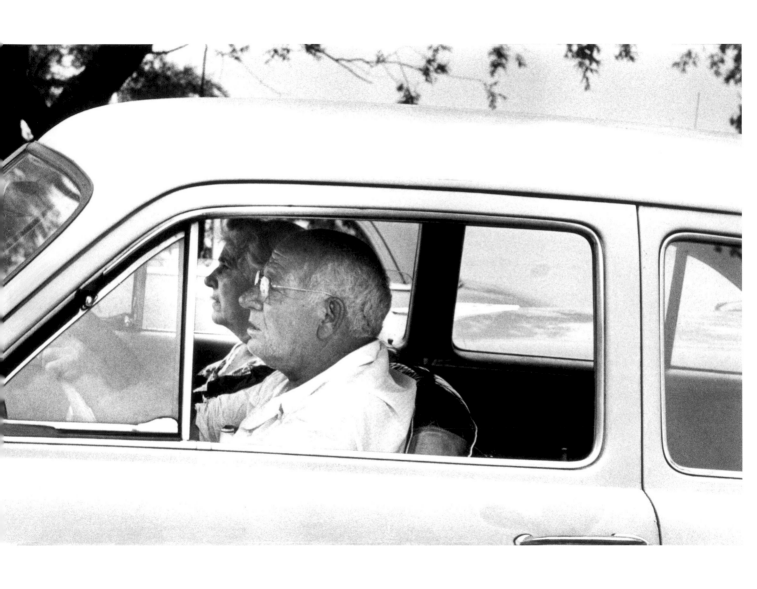

Chicago

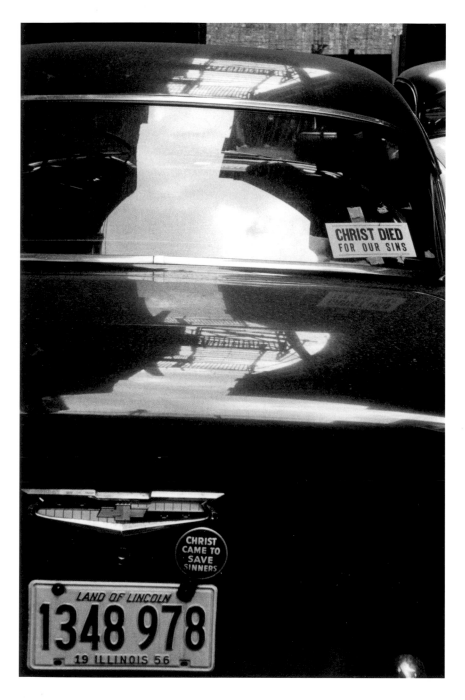

Public park — Ann Arbor, Michigan

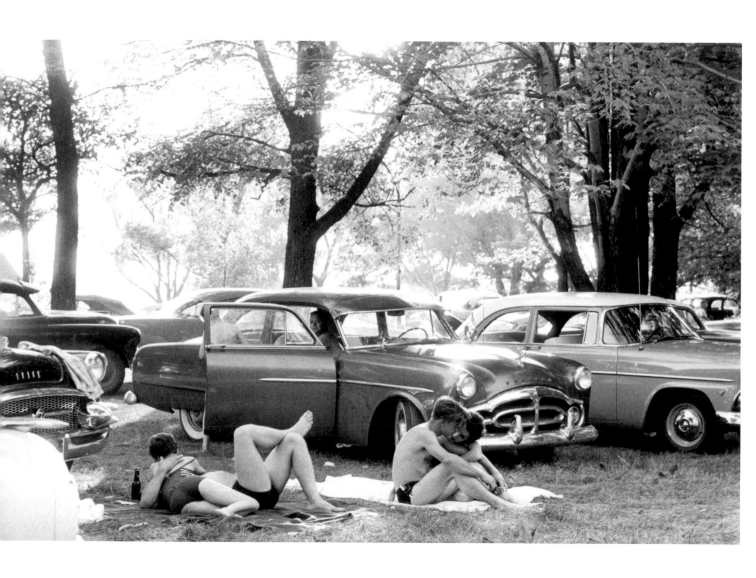

City Hall — Reno, Nevada

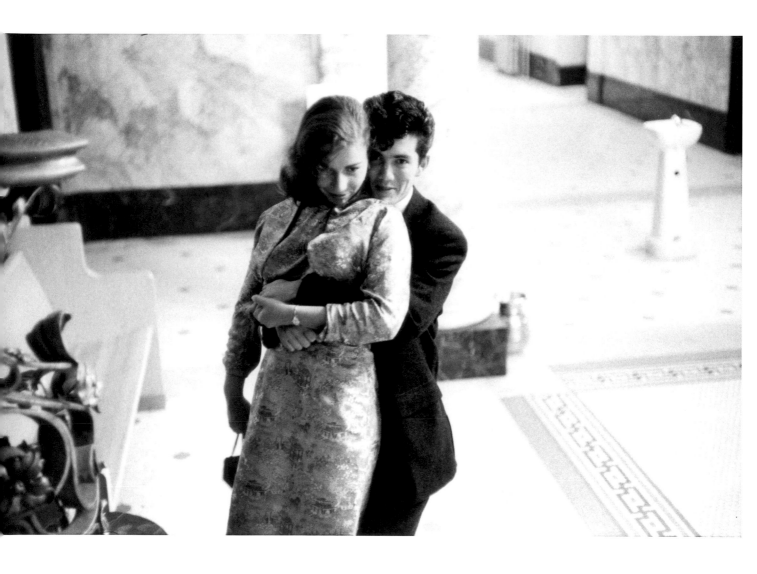

Indianapolis

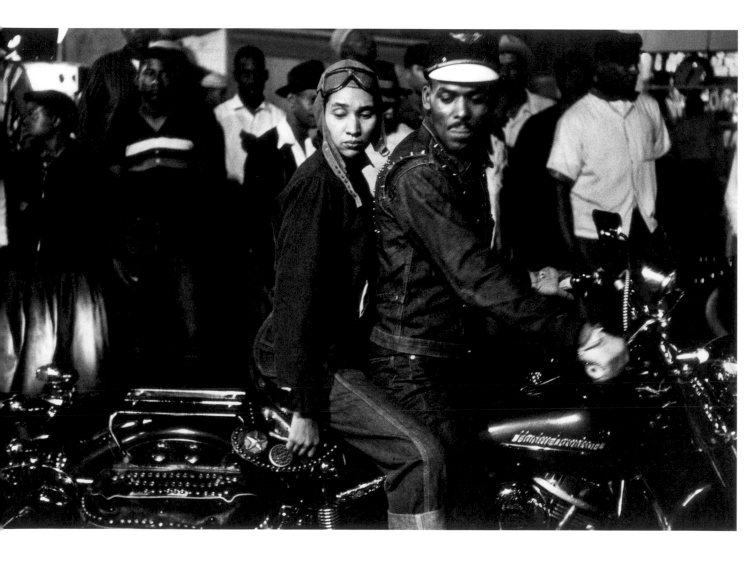

U.S. 90, en route to Del Rio, Texas

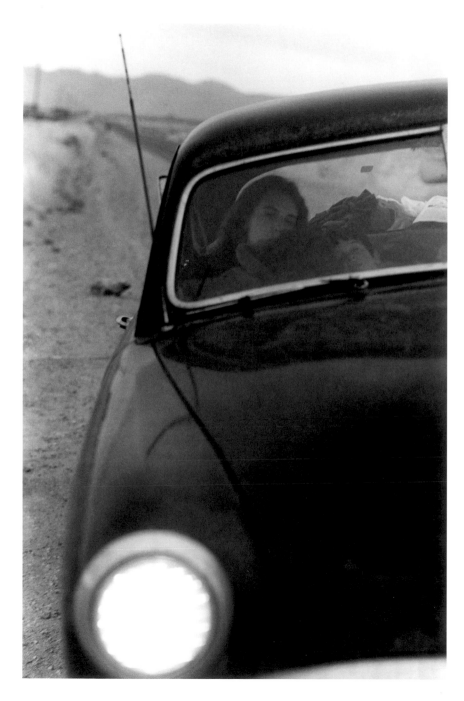

All photographs taken 1955 / 1956

First edition published in 1958 by Robert Delpire

First Grove Press edition published in 1959

First Steidl edition published in 2008

Book design: Robert Frank, Gerhard Steidl and Claas Möller
Reproduction: Steidl's digital darkroom
Printing: Steidl, Göttingen

Steidl
Düstere Straße 4 / D-37073 Göttingen
Phone +49 551-49 60 60 / Fax +49 551-49 60 649
E-mail: mail@steidl.de / www.steidl.de / www.steidlville.com

ISBN: 978-3-86521-584-0
Printed in Germany